Creative Ink Drawing

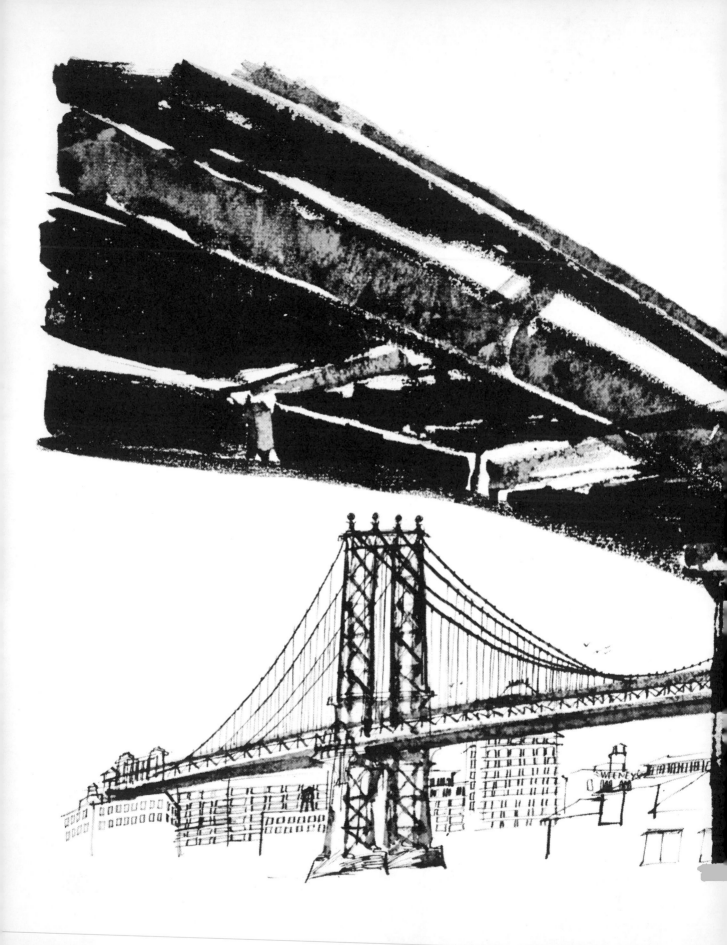

CREATIVE
INK
DRAWING

by Paul Hogarth

Watson-Guptill Publications • New York

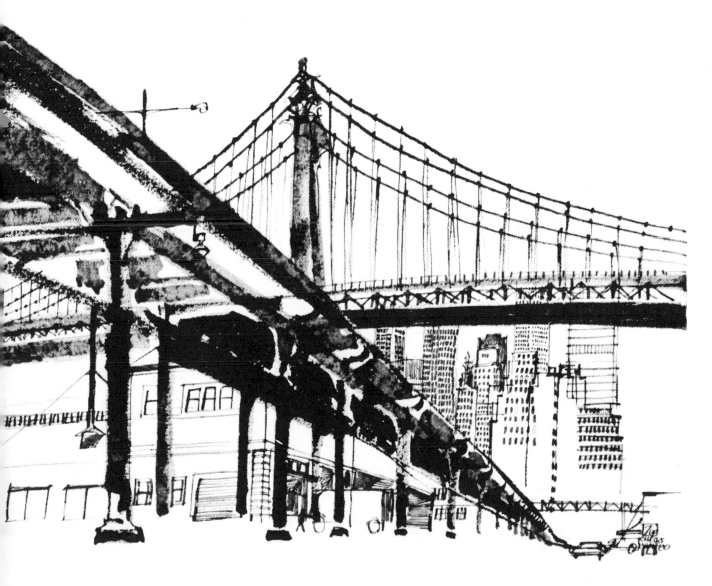

Copyright © 1968 by Watson-Guptill Publications
Published 1971 in New York by Watson-Guptill Publications,
a division of Billboard Publications, Inc.
165 West 46 Street, New York, N.Y.

Manufactured in the U.S.A.

ISBN 0-8230-1075-9

Library of Congress Catalog Card Number 68-12403

First Printing, 1968
Second Printing, 1972

Acknowledgments

This book is gratefully and affectionately dedicated to my wife, the painter Pat Douthwaite. Her helpful criticism and encouragement are a source of strength I always fall back on during my travels.

Special thanks are due to Donald Holden of Watson-Guptill, whose lively guidance never failed to stimulate and deepen my desire to finish the book, come what may.

I should like to thank Cassell and Company, London; Doubleday and Company, New York; Bernard Geis Associates, New York; the Hutchinson Publishing Group, London; Penguin Books, London; the Editors of *Fortune* and Time-Life Books, New York; the ACA Gallery, New York; Studio Vista Ltd., London; Hill and Wang, New York; and the Strathmore Paper Company, West Springfield, Massachusetts — all of whom generously granted the publisher permission to reproduce drawings of mine which they own.

For friendly assistance in the loan of photographs and originals, I should like to personally thank John Anstey, Editor of the *Weekend Telegraph;* Norman Snyder, Art Editor of Time-Life Books; Walter Allner, Art Director of *Fortune;* Richard Gangel, Art Director of *Sports Illustrated;* Diana Klemin, Art Editor of Doubleday and Company; David Herbert, Editorial Director of Studio Vista Ltd., London; Mill Roseman, Vice-President of the Lampert Agency, New York; and Deidre Amsden, for her excellent and concise illustrations which appear in Chapter 4.

The owner's permission to reproduce copyrighted works not in my possession, or works not in the possession of the publisher, is gratefully acknowledged after each caption.

Paul Hogarth
Cambridge, England

Contents

Books by Paul Hogarth

Drawings of Poland

Looking at China

Sons of Adam (published in Great Britain as *People Like Us*)

Brendan Behan's Island (with Brendan Behan)

Brendan Behan's New York (with Brendan Behan)

Creative Pencil Drawing (companion to *Creative Ink Drawing*)

Majorca Observed (with Robert Graves)

London à la Mode (with Malcolm Muggeridge)

Artist as Reporter

A Russian Journey: Suzdal to Samarkand (with Alaric Jacob)

Paul Hogarth's American Album

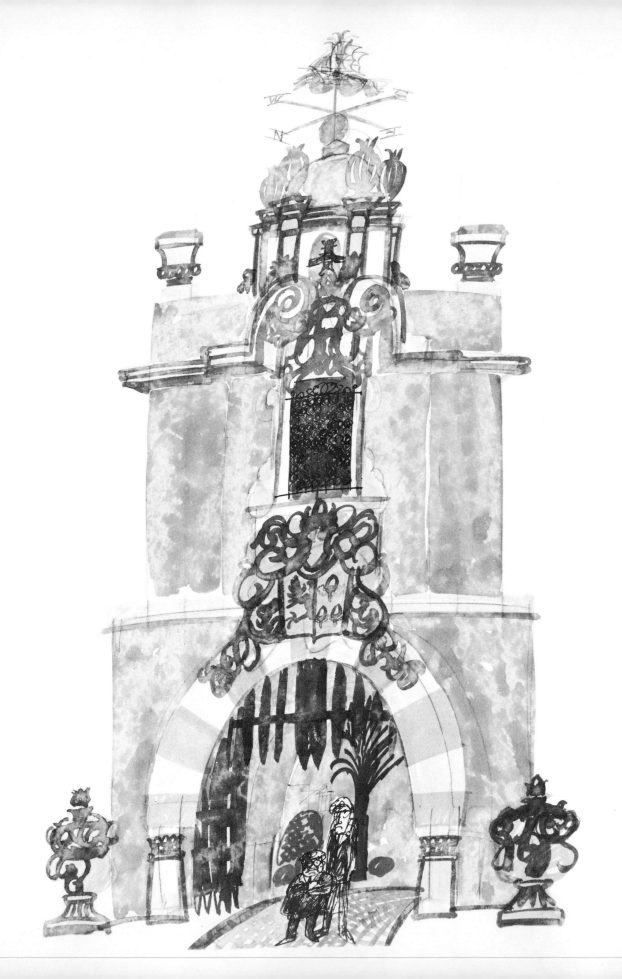

1/ Drawing with ink media

Just *why* one artist draws with a pencil, while another prefers to work with ink, is not easy to explain. The reasons are often purely psychological. For a long time, I took refuge behind the vagaries of graphite and charcoal because I had found a safe technique; I did not wish to risk all and lose confidence by trying the more sharply defined lineal discipline of ink media.

Pencil vs. Ink

But I knew that fluency in both pencil and ink was vital for my own development. In strictly practical terms, working in a single medium restricted my opportunities for publishing drawings in the bigger, more important magazines. But I felt unable to make the break with the medium I *thought* I had mastered. So, for years, I worked with graphite and charcoal leads. I became so facile that I not only bored myself, but everyone else, too, making one drawing after another in the same old way.

Things came to a head during the fall of 1960, while I was working in the United States. The subject matter I was concerned with had much to do with the break. The monumental silhouettes of nineteenth century American industrial architecture — with vast areas of brick, graced with the trappings of modern pop imagery — defied my well mannered renderings in pencil. Such subjects compelled me to think of drawings made with a fat brush charged with ink, blotted, then worked on with a fountain pen or felt-tipped pen. And this is how I made many of them.

Self-Discovery in Drawing

I found that ink had many different qualities that could free me from the rut I had got into. I discovered that I could be far less literal, far bolder, in attempting a more

The Vanderbilt House, Centerport, Long Island, 1965. *Eagle's Nest, the favorite country residence of the great railroad tycoon, is one of those larger-than-life places which reaches into the pocket of every idiom of architecture known to man. The mock Hispano-Moorish entrance gate was drawn with markers and brushline because I thought this combination would convey the fantasy of it all. After making a rough pencil outline on a sheet of Strathmore buff paper, I worked with a brushline of diluted Higgins India ink, blotted for lively tonal effects, and worked over with an orange Faber Markette. The two custodians and the window grill were drawn with an Esterbrook fountain pen and Pelikan Fount India ink. Courtesy, The Strathmore Paper Company, West Springfield, Massachusetts.*

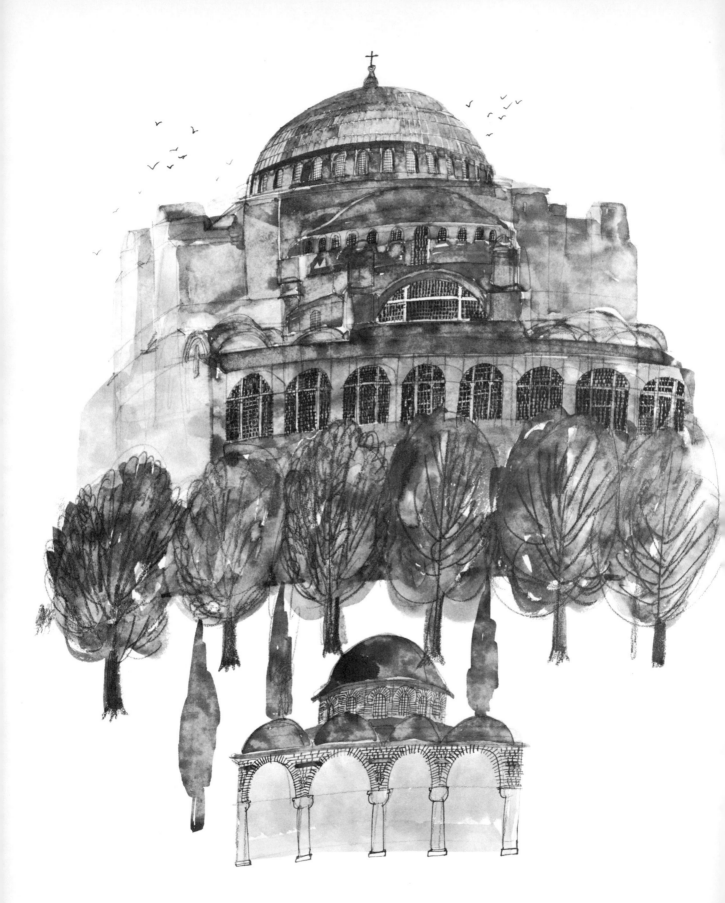

stylized, more dynamic way of drawing. Two long felt desires—to work in a more painterly manner and to try my skills as a social satirist—were at last effectively synthesized.

Switching from one medium to another is not, of course, the key to your success as an artist. This depends more on the intensity of your personal drive to succeed, the influence of a great artist, or, most of all, the opportunities you get to show what you can do. But trying new media could well be the key to becoming a better artist in creative terms, simply because you may find a medium that best suits your personality, your ideas, and your creative development.

Just as a child works more freely with a brush or a marker, you may feel more at home working with a felt-tipped pen, rather than one with a fine steel point. In discovering *what* medium really suits you, you will have begun that process of self-discovery which is vital for the development of your ability.

In *Creative Ink Drawing,* as in my previous book, *Creative Pencil Drawing,* I deal mainly with my personal approach to drawing and with how my own ideas were formed. I hope that these explorations in both traditional and modern ink media will help you—as it did in my own case—to increase the versatility and expressiveness of your drawing.

The Hagia Sophia, Istanbul, Turkey. *One of a series of historical illustrations depicting life in twelfth century Constantinople for Time-Life Books. These illustrations were made on location, revealing what lay half buried under later Turkish achievement or modern buildings. Fortunately, Hagia Sophia is gloriously intact; all that had to be transposed was a crucifix instead of a crescent atop the great dome. To help convey more atmosphere, yet at the same time observe a certain accuracy of detail, I made this drawing with successive washes of diluted India ink, using a Japanese brush on a foundation of soft graphite pencil. Details such as windows were added with a Gillot 303 steel nib and undiluted ink which was allowed to dry. The small church was brought in from nearby to emphasize the great church's massive grace. From Byzantium, a volume in The Great Ages of Man series, Time-Life Books. Courtesy and copyright, 1966, Time, Inc.*

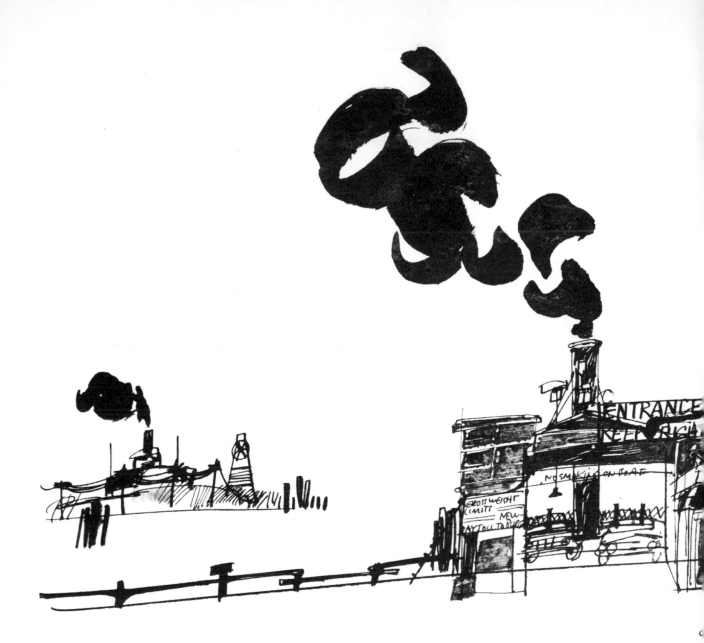

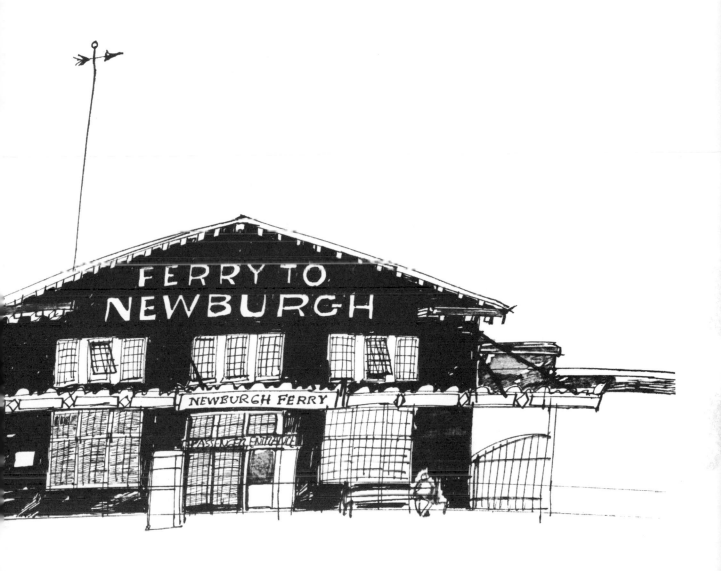

Beacon Ferry, Hudson River, New York, 1963. *I find an ordinary school nib and a large brush an ideal combination for making this type of drawing quickly and effectively. In this case, I used a Spencerian steel nib and a Japanese brush with Higgins manuscript ink, in a 14″ x 17″ sketchbook of Daler cartridge, a sturdy white paper.*

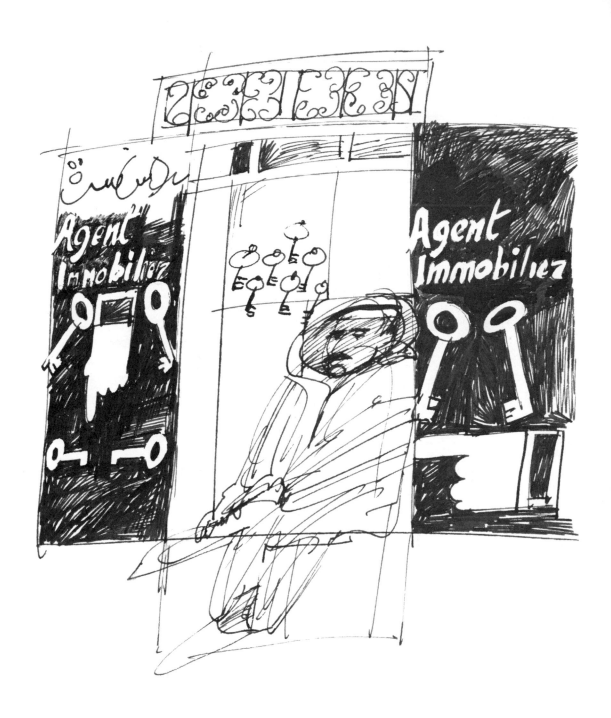

Real Estate Broker, Marrakesh, 1966. *The flexibility of ink is shown in this rapidly made sketchbook drawing. Rendered in a Planet sketchbook, 5″ x 7″, with an Esterbrook fountain pen. Courtesy,* Weekend Telegraph, *England.*

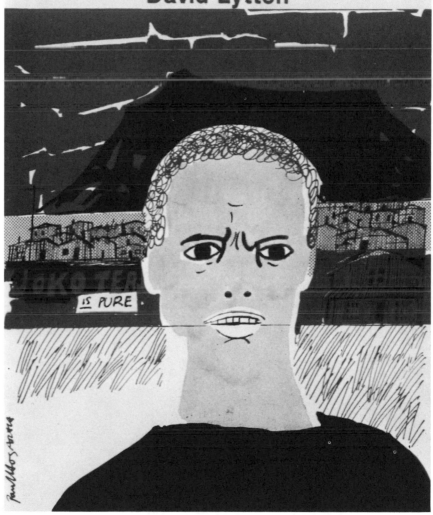

Book Jacket, 1962. *A design which shows use of a steel pen, brush, and diluted ink wash, combined with Zipatone. Courtesy, Penguin Books, England.*

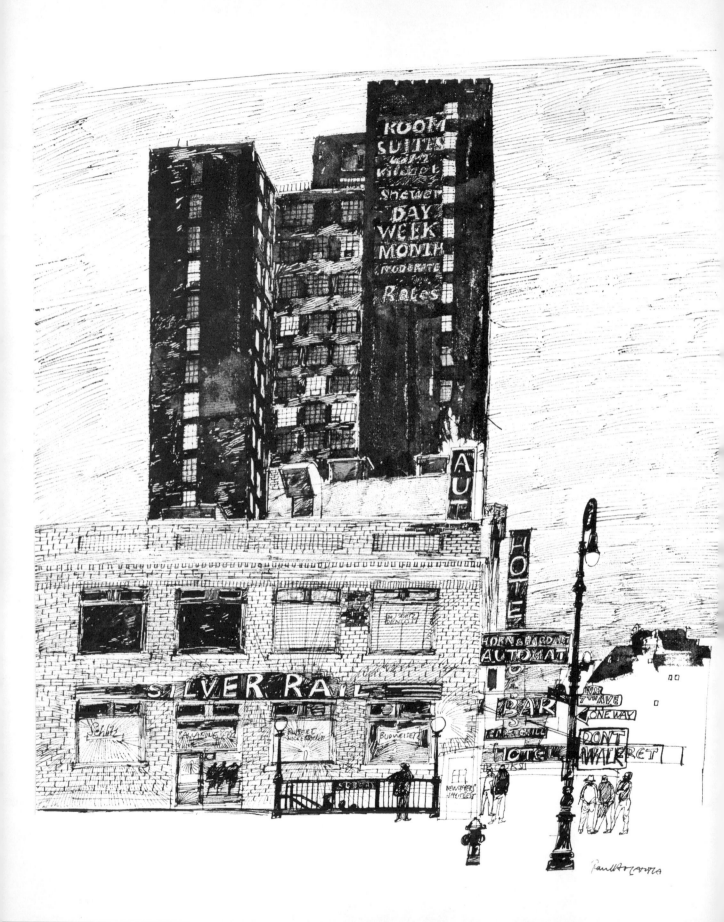

2/Materials and tools

Unlike drawing with a pencil—which allows you to make a decision, then change your mind at various stages of a drawing—the bolder, more committed qualities of ink media usually call for a decision to be made *before* you actually begin. So it is good practice to be aware of what your materials and tools are capable of doing. This awareness, in turn, enables you to adjust your approach in order to develop your own personal way of handling various ink media.

Begin Simply

Ink drawing today covers a wide range of media, including both traditional and modern tools and materials. Hardly a year goes by without the introduction of some new or improved type of fountain pen, felt-tipped or fiber-tipped pen or marker, or some new ballpoint—so much so that it becomes difficult to resist buying them and trying them all out. While this is not a bad thing to do, I think it is best to hold off doing so until you have gained some practice with more traditional tools. This practice could enable you to handle the modern media a great deal more effectively.

A Chinese or Japanese brush, a steel pen, and a sheet or two of blotting paper are all you will require at first—but they will be more than sufficient to explore the potentialities of ink. Later, you can always move on to the more elaborate pens and markers.

The Silver Rail, New York City, 1963. *This was one of my earliest location drawings made in ink. Now closed, the Silver Rail bar on the corner of West 23rd Street and Seventh Avenue is already part of history. The clientele there was somewhat predatory, dividing its time between the Horn and Hardart automat next door, the sidewalk, and the bar itself. But men of substance were well remembered. Located on the same block as the Chelsea Hotel, the Silver Rail was much used by Dylan Thomas and Brendan Behan. "Whatever happened to those two fat guys?," I was asked in 1964. "They wuz good company!" The place had a peculiar splendor at night when it radiated an inviting brilliance reminiscent of Van Gogh's Night Café at Arles. The same lone onlooker differed, however: "There's nothin' good or beautiful about this part of Gotham at night," he shrilled, standing before me like an unfrocked priest. "Include me out of those standees, sir!" This drawing was done in Higgins manuscript ink with an ordinary school nib, a Gillot 303 nib, and a No. 6 sable brush on Saunders paper. From* Brendan Behan's New York, 1964. Courtesy, Hutchinson Publishing Group, London, and Bernard Geis Associates, New York.*

Traditional Pens

Drawing with ink, therefore, not only means working with the more traditional tools —the quill, reed, bamboo, or steel pen—but also the Flomaster, the Pentel, and a whole host of felt-tipped and fiber-tipped markers.

My own ink drawing media consist mainly of Chinese or Japanese brushes, fountain pens, steel pens, and felt-tipped or fiber-tipped pens and markers. Occasionally, I also use quill and bamboo pens.

Drawings of an almost *written* nature are possible with the quill (hollow stem of a feather) pen, the best of which can be cut from goose or turkey feathers. The bamboo pen is also sympathetic to work with; it is a sturdy, flexible tool which can either be purchased at an artists' supply store already cut, or cut by yourself from the small, thin bamboo flower canes readily available in your local garden supply or hardware store. (See Chapter 4 for instructions on cutting quill pens and reed pens.) The only drawback to using quill or bamboo pens is the constant dipping that is necessary, because they hold so little ink.

Pens with steel nibs require almost as much refuelling. But the variety of nibs (short, long, stiff, flexible, thick, thin, etc.) is immense and the line can be as fine or as bold as you want it to be. These range from the special types made for artists (like the English Gillot nibs) to the humble nibs made for school children to write with. At times, I indulge myself with a Gillot 290 or 303, or an Esterbrook 355 or 357, all fine, flexible artists' drawing nibs. But usually I work with a nib like the inexpensive No. 5 Spencerian, a tough, resilient school nib.

Choice of the right holder is important when you draw with a steel nib. A spindly pen holder is seldom of use as it differs in grip and weight from the pocket pen you are probably used to. So be sure to get a penholder that is about the same in thickness and weight as your favorite fountain pen or ballpoint.

Fountain Pens and Ballpoints

The modern equivalents of these traditional instruments of ink drawing are probably more convenient for today's artist. Fountain pens, ballpoints, felt-tipped or fiber-tipped pens, and felt-tipped markers can be carried around in your pocket without fear of jabbing yourself or staining your clothes. You can work continuously with them without pausing to refill, and they are now capable of producing a line both sensitive and varied.

The pen that carried its own supply of ink was a dream of poets and artists. Oriental scribes solved the problem by using elegantly engraved boxes for reeds and containers for ink. Then, in 1809, the first "reservoir" pen was patented by Englishman John Sheaffer. But it was not until 1884 that Lewes Edson Waterman invented the world's first practical fountain pen, which could be filled by unscrewing the nib and squirting ink in with a dropper.

Using a fountain pen, however, posed a problem for artists. Because the mechanisms of these pens were invariably delicate and intended for use only with thinned

writing inks, they could seldom be used for making small sketches or notes. If drawing inks were used, they would clog the pen and the swift movements of drawing would damage the nib. The pens of today, of course, are much more durable in every way. Special inks have been introduced which are suitable for fountain pens and which are also intense. Parker and Sheaffer fountain pens are now as good for drawing as they are for writing. So is the tougher and less expensive Esterbrook pen, which, in *my* hands at least, stands up best of all to the vigorous pressures of drawing.

More specialized fountain pens, designed to take India ink, include the English Osmiroid 65, with over thirty different interchangeable screw-in nib units; the king-size French Mont Blanc, a large reservoir model; the sturdy American Ultraflex artists' fountain pen; and the versatile German Rapidograph.

Ballpoint pens, which (at one time) I would never have thought of using for drawing, are constantly improving. Best of all are those made for reproduction with office photo-copying equipment, like Friem's Repro-Pen and USA Commercial's Illustrator. These are available in fine and medium grades and use a permanent black indelible ink that dries instantly. Especially good is Tauhman's artists' ballpoint India ink pen, a smooth running, long lasting, replaceable cartridge type that is a pleasure to use.

On the whole, however, I still do not find ballpoints sufficiently sympathetic for any purpose other than making notes in a small sketchbook.

Felt Tips and Fiber Tips

More recent innovations in ink media include the felt-tipped pen and the felt-tipped marker. These are excellent to draw with and are far removed from the earliest felt-tipped pen, with its somewhat thick and uncontrollable black line which "bled" through the thickest paper. The best of the latest improved types are undoubtedly the Faber Markettes. They are available with square or pointed tips; their brilliant colors not only mix well with each other, but also with pencil and other ink media. A thinner line is produced by the Faber Markette Thinrite Marker, which has the startling versatility of both pen and brush. It comes in a pointed tip and is indelible.

The first addition to the basic writing and drawing tools of man since the invention of the fountain pen appeared in the early 1960's. This was the Japanese Pentel, a nylon-tipped pen which combines both brush and pencil in one fluent, expressive line. Available in small and large sizes — and in the three basic colors of blue, red, and black — the Pentel is a remarkable drawing instrument because it combines the drawing qualities of brush and pencil.

At the present time, the Pentel has many rivals. The chief competitors have concentrated on evolving even greater sensitivity of line with various kinds of plastic tips, which are constantly being developed and improved upon. The latest and best of these are the Faber-Castell Presto and the Esterbrook Color Pen. Both instruments can draw on almost any surface, on any kind of paper, and are available in colors — the Presto in three colors, the Esterbrook in eight.

Inks

Whether you choose to work with a quill, a steel nib, a fountain pen, or a brush, the right ink could make all the difference to your drawing. For example, India or Chinese ink (the most common artists' drawing ink) is sold in two varieties: the *waterproof,* which will withstand washes even after it has completely dried; and the *soluble,* which may be washed away with water, a clean brush, and blotting paper. Both may be freely diluted with water (preferably distilled).

The heavier, waterproof variety, made with shellac and borax, is best used with a steel or bronze nib, and with special types of artists' fountain pens. Ordinary fountain pens will not function for long if used with this kind of ink. If you like to work with the fountain pen you write with, do so, but make sure that you use the soluble variety of ink, or better still, the special inks which do not contain the harmful corrosive agents that destroy the insides of a fountain pen. I have found the best of these to be Pelikan Fount India. I also recommend such excellent drawing fluids or document inks as the German Pelikan Drawing Black; Sheaffer's Skrip; Higgins Eternal; and the Dutch Gimborn Acten-Inkt. All these are permanent, so that your drawings will not fade and lose their strength.

If you are working with a quill, reed, or bamboo pen, you will need to use the thinner, soluble variety of India ink, rather than the waterproof variety you might use with a steel nib. Although reeds and bamboo pens can also be used with American and European inks, the best inks for them are India or Chinese ink, which are specially made for use with the wooden pens and pointed brushes of the oriental artist and calligrapher. Such pens are at their best with these inks, which are sold dry, in slab or stick form, and prepared for immediate use by being rubbed down with water on stone blocks or troughs devised for the purpose. Both sticks and troughs are obtainable in most well stocked art supply stores.

In China, where ink was manufactured as long ago as 2500 B.C., stick ink is marketed like wine. Stocks are put down each year and carefully labelled. The older the ink is, the finer the quality. Artists' supply stores stock the gilded sticks, in all sizes and thicknesses, in great trays. Good India or Chinese ink is recognized by its brilliant black fracture or texture. There should be no deposit or precipitate when mixed with even large amounts of water. The cheap varieties, available in oriental emporiums in Europe and the United States, are usually made for immediate sale and immediate use and these are usually not as permanent.

Choosing a good ink at the right price is almost an art in itself. In the Far East, cobwebbed trays are solemnly brought out for your inspection by priestlike assistants, while you sip a slender cup of jasmine scented tea and reflect on the infinite variety available. Having bought a good ink, you then have to consider the purchase of a stone trough on which to rub the ink down. This, I was told, should be *very* carefully chosen and should not be too porous or too smooth. The main virtue of stick ink is that it has almost the tonal range of watercolor, a quality that is, perhaps, not quite so necessary in the vigorous expressive imagery of western drawing.

In both Europe and America, India or Chinese type inks are made up in fluid form by Higgins, Reeves, Winsor & Newton, and Pelikan. The inks are available in both black and colors. These are of good quality and combine well with both ink and pencil media.

Another less conventional drawing fluid, both inexpensive and sympathetic to use, is ordinary water-based stain. I have seldom used this, but my friend Ronald Searle used this medium for many years (and as far as I know, he still does). It is similar to *bistre,* the brown pigment made from charred wood, which was much used by Rembrandt and other artists of the seventeenth century. Searle found the commercial black writing inks too insipid for use with the reed and bamboo pens he had become accustomed to using as a prisoner of the Japanese during World War II. As India ink in stick form was unobtainable in England for many years, he turned to the local hardware store for the floor stain, which substituted for a thin, intense ink.

Brushes

I usually work with a Chinese or Japanese pointed brush. This type is available in various qualities and prices, according to the kind of hair used. As it is a brush designed for use with ink, it is very durable. Moreover, one such brush is the equivalent of a good half dozen of the western type. I get my fine lines by using the point, and produce thicker lines by simply increasing the downward pressure. The whole brush can also be charged with ink to fill in solid areas or washes. Always wash out a brush in warm, soapy water as soon as possible after use.

Papers

The more traditional tools work best on the kind of papers they were originally designed for. The papers of the orientals and the old European masters were much more absorbent than modern western papers, soaking up the ink rather than allowing it to lie on the surface. It is this that contributes so much to the characteristic softness and sensitivity of old master drawings. Drawings made with soft-tipped tools like wooden pens, sticks, or reeds (as well as brushes) work superbly on modern absorbent papers such as the Japanese Sekishu and Mulberry. They work just as well on Strathmore, Ingres, and Abbey Mill charcoal papers.

Remember, the finer the point or nib, the smoother the working surface will have to be. An obvious example is bristol board, which is excellent for the finest, most delicate line drawn by steel nibs like the Gillot Crowquill. I prefer to work on a surface which offers more resistance — on paper such as Strathmore Drawing.

In fact, most good quality, smooth white drawing papers (called cartridge in Great Britain) are excellent for ink media, including felt-tipped markers. If you are using these markers, however, make a special note to avoid most charcoal papers, which will make your drawing look as if it had been drawn on blotting paper — unless you have some special reason for wanting this effect.

Sketchbooks

You may prefer to work in a sketchbook, as I do, with ink media. In this case, choose a sketchbook made up of good quality white paper (cartridge). For ink drawing, I find that I use sketchbooks in a smaller size than I do for pencil drawing; I have become used to a 10" x 14" book for larger drawings and 6" x 8" for smaller work. I also carry a 3½" x 4½" sketchbook of transparent, smooth paper to scribble notes, details, and ideas with a ballpoint or fountain pen.

Blotting Paper

This is necessary for pen and brush drawing, not only to blot wet passages and thereby accelerate drying — thus making sure your drawing does not get smudged on completion — but also for extending the range of tonal and textural effects in a drawing.

For example, a tonal effect can be obtained by instantly blotting a passage of *diluted* ink, which can be worked over, when thoroughly dry, with a stronger wash or line of *undiluted* ink. This technique is discussed more thoroughly in Chapter 6.

If you do work in this way, it is essential that you use blotting paper of good quality in order to insure that the wet ink is swiftly and efficiently absorbed without smudging. Blotting paper of poor quality will never entirely absorb the ink.

General Equipment

In addition to your various pens, nibs, and holders, you will need a sharp pocket knife or blade. This is for cutting quills and reeds; cleaning dried ink and other debris from your tools; scraping, scratching, and correcting your drawings.

If you are working on location with single sheets of paper or a large sketchbook, you will need spring clips and a light portable stool.

Pens and brushes should be carried in separate containers or carriers (metal cylinders are best) and spare nibs stored in small aluminum or plastic boxes to protect them from possible damage. Inks should always be carried in plastic bottles and placed in plastic bags so that any possible leakage can be effectively localized. A large box of cleansing tissue is also useful. So is your own water supply in the form of an artists' water container with a dipper which clips over the screw-top. An army canteen with a fitted cup will also do the job.

These items are best carried in a satchel or a shoulder bag. Your sheets of paper and sketchbooks, plus a sheet of light hardboard for a drawing board, are best carried in a canvas, plastic, or zippered leather carrying case or portfolio.

Plaza Santa Catalina Tomas, Palma, Majorca, 1963. *At the far end of the main street of Palma, the tree lined Borne, stands a modest pension housed in an* art nouveau *block which is reputed to have been designed by the great Catalan architect, Antonio Gaudí. Drawn with a Spencerian school nib in Higgins ink on Saunders paper. From* Majorca Observed, *1965. Courtesy, Cassell and Company, London, and Doubleday and Company, New York.*

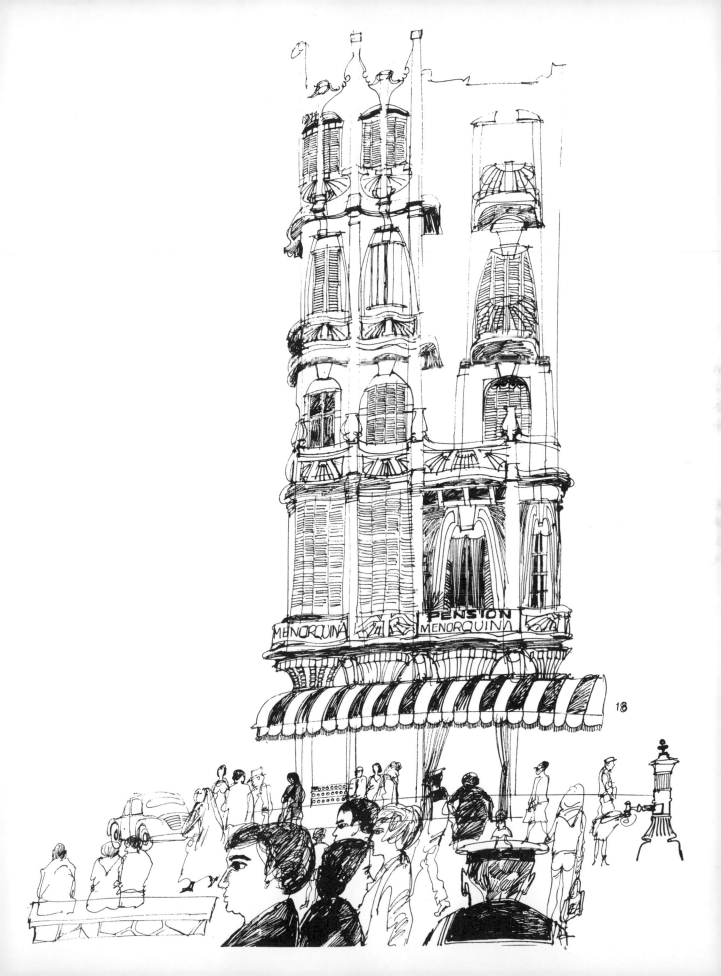

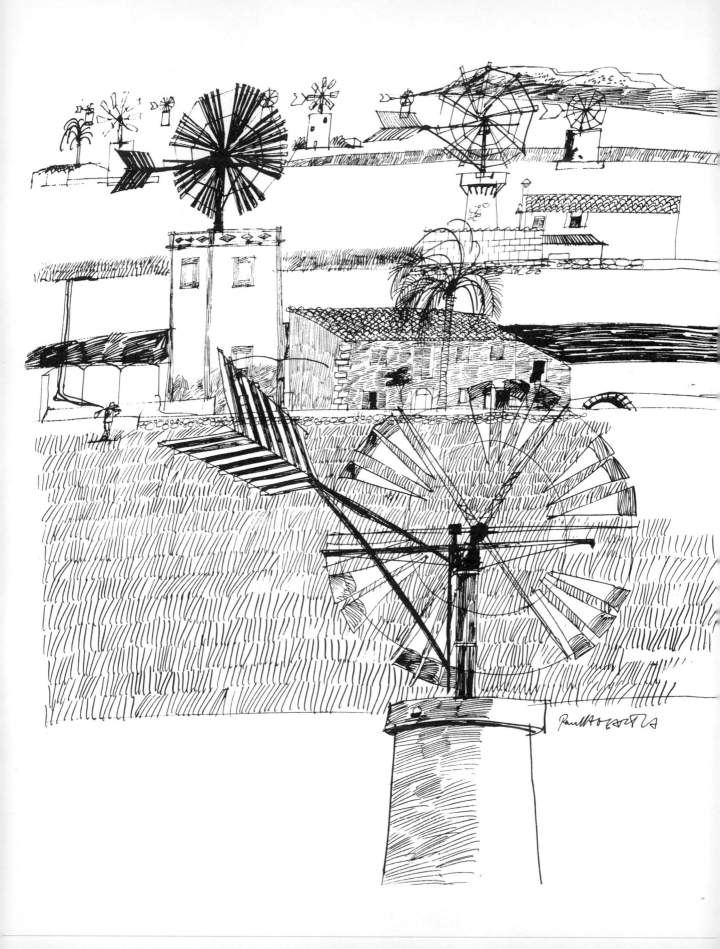

3/ Drawing with a steel pen

Drawing with a metal nib has an obvious affinity with writing; thus, the metal nib or point will probably be the drawing tool that comes most easily to you. Whether a steel school nib, an artist's bronze crowquill, a fountain pen, or a ballpoint pen, the choice will depend on which you feel at ease with. But the metal nib is a tool you will be able to use and master without undue difficulty.

The best way to get started is to familiarize yourself with a group of various nibs by drawing as much as you can with them. These can be chosen almost at random in any art supply store, providing you can get nibs that cover the three main types (heavy, medium, and fine). Do not worry about whether the nibs are artists' quality. I *began* working with artists' nibs, but went back to school nibs because they were inexpensive and expendable. I worked with these for a long time before I graduated to using a fountain pen. Working with these ordinary nibs, I wanted to develop a fluent, running line of my own without feeling that I was using a special nib, and without avoiding the problem by depending on a fountain pen.

Choosing Nibs and Holders

There were three basically different nibs which I found sufficient to give me the widest range of lineal and textural effects. These were a sturdy, school nib like Spencerian for swiftly drawing long, sweeping lines non-stop from one side of the paper to the other; a Gillot 303 or 404 for tackling general detail; and a Gillot 290 for the really fine accents. I use these nibs or their equivalents for all kinds of drawings on location and in my studio.

I also discovered that if my penholder was as thick as my writing pen or fountain pen, and had the same *feel,* it made me more at ease. This also helped rub out the memory of drawing with spindly "mapping pens" which, for me, meant ink drawing at art school. Penholders, I might add, come in all shapes and sizes in aluminum and wood. Some even have a very useful release mechanism for the painless extrac-

Windmills Near Palma, Majorca, 1963. *The rich orchards of the island's central plain, with their windmills turning incessantly, are great places for landscape drawing. Every visible shape and texture is exploited to convey a gentle, yet exotic atmosphere. This drawing was made with Gillot 404 and 290 nibs, using Higgins India ink on Saunders paper. From* Majorca Observed, *1965. Courtesy, Cassell and Company, London, and Doubleday and Company, New York.*

tion of unwanted nibs. I generally use a good, medium-thick holder with a spiral or milled grip, or a really thick one that is smooth. Each of my three nibs has its own holder.

Work Method

I usually begin with a fairly clear idea of the image I want to make, based on what I have witnessed or remembered. Working directly from any rough notes I may have made for composing the drawing, I make a start by roughing in a general outline with an HB pencil. This is no more than a few faintly drawn lines on which to hang the drawing; at this stage, I use pencil not because I feel any uncertainty, but because I am anxious to get it all in.

I then begin to work in ink, working from the top, left hand side of the paper. My left hand is on a sheet of clean white blotting paper. I work rapidly, first with the school nib, drawing in the strong, emphatic shapes. I then change over to a second pen, using a medium Gillot 303 or 404, and work at a slower, more careful pace. I alternate one nib with the other, using the restraint of the 303 against the strength of the school nib, and saving a third pen, the Gillot 290, for any delicate drawing that may be required.

I often work the other way round, or start from the middle and work outwards. I may begin with a fine nib, then switch to a medium, finally using a school nib for the stronger passages. Just how I work depends on whether I have a pictorial idea that I can successfully construct from the beginning, or whether I am working intuitively, probing for a pictorial idea that will emerge in the process of drawing.

Before I began the drawing *Art Nouveau House in Majorca,* I had a very clear idea of how I would do it, almost to the last stroke. The only decision I had to make was whether to draw with one nib or three. The intensely decorative facade of the house could be drawn with a Gillot 303 nib. If I used this nib throughout, however, I would not be able to achieve the subtle distinctions between brick, stone, and iron, together with other elements like trees and passing figures. I decided that a variety of lineal effects was very necessary, and that the subject should be drawn with fine, medium, and heavy nibs.

I worked in three overlapping, rather than consecutive, stages. First, I needed a stout nib to erect the framework of long lines. Second, I used a Gillot 303 for general detail, such as the circles and curved lines of stone. And finally, I selected a Gillot 290 to render the finer lines of shutters and blossoms.

The drawing *Palma Signs,* on the other hand, emerged completely spontaneously. I had seen these brandy bull billboards everywhere on the outskirts of the city and felt compelled to draw one, selecting the billboard which was close to where I was living. I had no clear idea how my drawing would work out, but I liked the bull on the billboard so much that I drew it in with a brush, delineating the words of the ad with a stout school nib. But the bull sign did not succeed as an image in itself. I paused to look at the various signs and buildings around me and realized I was observing a microcosm of change. Soft drink signs and an urban development project contrasted

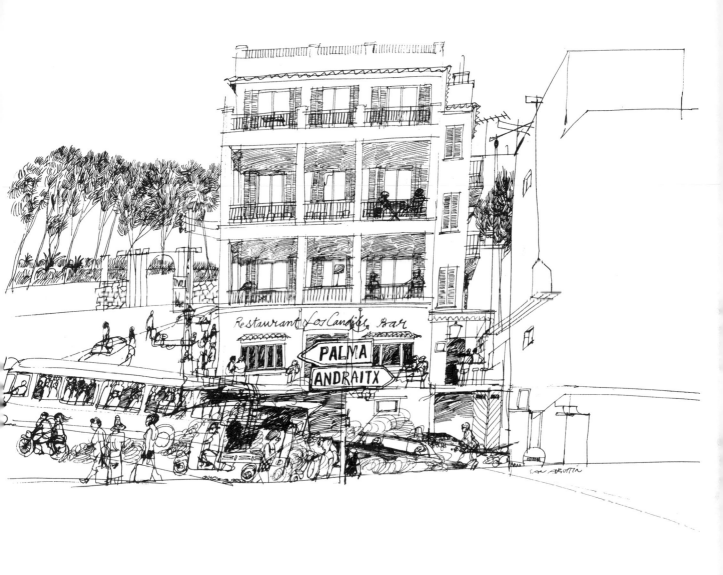

San Augustin, Majorca, 1963. *Ink is just as able to catch movement as graphite pencil. A Spencerian nib was used for the static architectural background, and a Gillot 303 for the continuous stream of passing traffic. Drawn with Higgins Eternal ink on Saunders paper. From Majorca Observed, 1965. Courtesy, Cassell and Company, London, and Doubleday and Company, New York.*

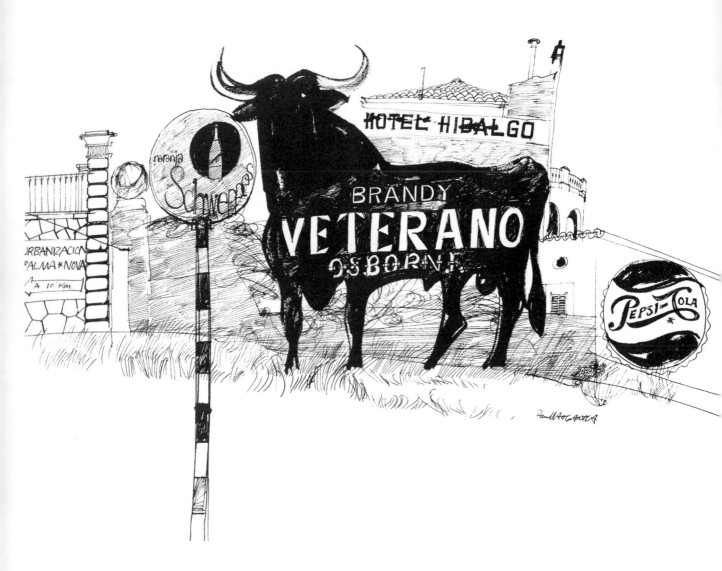

Palma Signs, Majorca, 1963. *Significantly symbolic imagery can usually be found on the fringes of any city. This drawing was made with an ordinary school nib and Higgins India ink on Saunders paper. From Majorca Observed, 1965. Courtesy, Cassell and Company, London, and Doubleday and Company, New York.*

with the traditional bull—a symbol of virility—and with the crumbling hotel whose name belonged to the distant past. I drew in these disparate elements, and my drawing was complete.

Working with Fountain Pens

Most of the work I have done with a fountain pen has been confined to sketchbooks. These drawings were usually made in situations where any conspicuous equipment (other than a small or medium size sketchbook and a fountain pen) would have made me the object of unwelcome attention. A good, reliable pen is essential on these occasions.

Fountain pens, however, do have the habit of behaving oddly with different people. After trying out (and wearing out) several expensive Parker and Sheaffer pens, I now rest content with a perfectly plain, regular black Esterbrook. I use this with Pelikan Fount India or Pelikan Drawing Black.

I have also used—without success—the various artists' fountain pens specially made for use with India ink. Though many artists swear by them, their delicate mechanism requires patient, constant maintenance which I find difficult to keep up with. Another type, the Rapidograph, I find more suited to the needs of technical illustrators or architectural draughtsmen—who work rather deliberately—than to my kind of artist, who works spontaneously and impulsively.

Working with Ballpoint Pens

After the steel nib and the fountain pen, the next best tool is a good ballpoint. And there are some good ones about now, like the Rapidoball, a ballpoint with a "jewel" ball in a metal tube, using regular liquid ink—not, strictly speaking, a ballpoint. The Taubman cartridge-type ballpoint India ink pen *is*. Both permit a widely expressive line never before possible with this type of pen.

Because they are not strictly artists' pens, ballpoints can be very useful under certain conditions. I once made a series of sketches of gambling addicts in Baden Baden, Germany, with a Parker ballpoint. To avoid the rigorous ban on any kind of drawing and photography at the famous Casino, I pretended to make calculations on one page of a 5" x 3¼" Winsor & Newton sketchbook, while I made drawings on other pages. Ronald Searle worked in the same way with a ballpoint pen, but, unfortunately, became so absorbed in drawing the variety of characters at the roulette table in the Green Room, that he soon felt a firm hand guiding him—outside!

As with a fountain pen, a ballpoint is very convenient for drawing in difficult places. I regularly work with them in dance halls, and nightclubs, as well as gambling houses—in fact, on all occasions where I have to work fast and remain as inconspicuous a part of the background as possible!

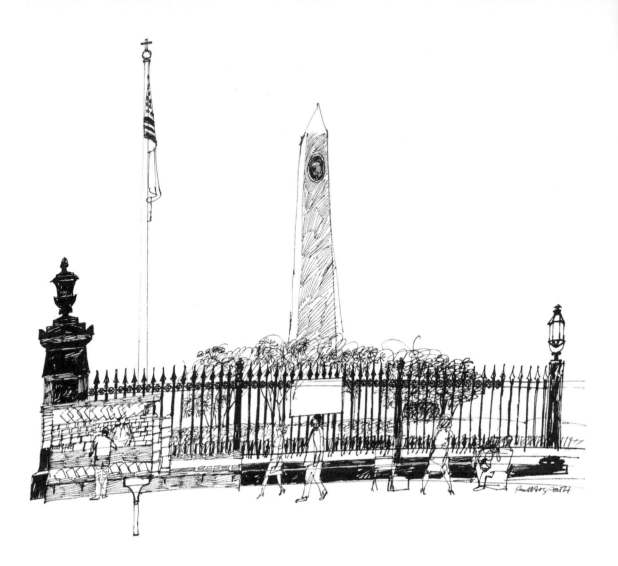

The Emmet Memorial, New York City, 1963. *(Above) Standing in the churchyard of St. Paul's on Broadway, this granite obelisk is not a subject I would generally notice, let alone draw. It celebrates, somewhat illegibly, the memory of Thomas Emmet, the brother of the Irish patriot, Robert Emmet, who took part in the struggle for American independence. Brendan Behan particularly wanted me to draw it. After a reconnaissance from inside and outside the churchyard, I thought the only effective way to do so would be to place the obelisk in some kind of setting. I used a thick and well tried school nib and a Gillot 303 to emphasize the contrast between the heavy, ornate black iron railings and the lighter obelisk. Passing figures were added to enliven the scene. Drawn with Higgins India ink on Saunders paper. From* Brendan Behan's New York, *1964. Courtesy, Hutchinson Publishing Group, London, and Bernard Geis Associates, New York.*

Congregational Church, Windsor, Connecticut, 1963. *(Right) I found a steel nib ideal for conveying the puritanical severity of this fine old wooden church. I drew the building with a Spencerian school nib, the gravestones and shubbery with a Gillot 303. I used a Japanese brush to fill in the solid areas. Drawn with Higgins India ink on Saunders paper. Courtesy,* Fortune Magazine. *Copyright, December, 1963, Time, Inc. Collection, Mr. Tom Mathews, Cavendish, England.*

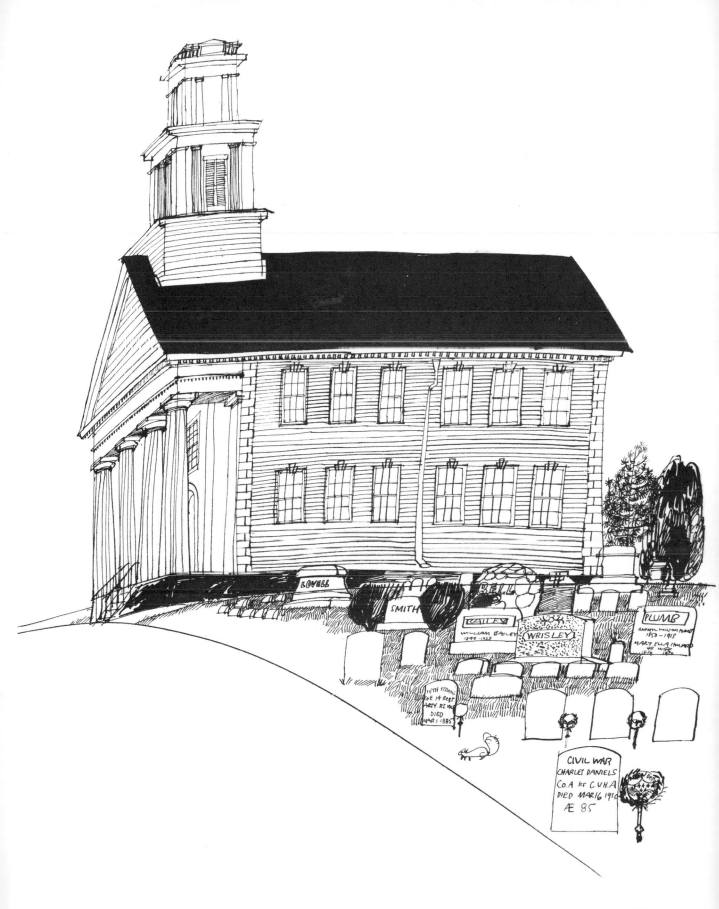

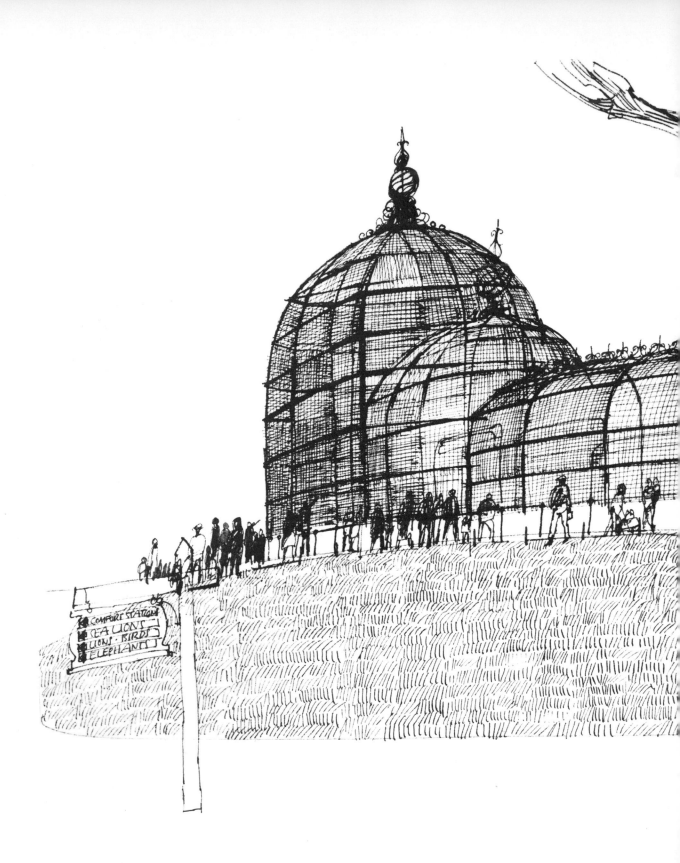

The sign in the illustration reads:

COMFORT STATION
SEA LIONS
LIONS · BIRDS
ELEPHANTS

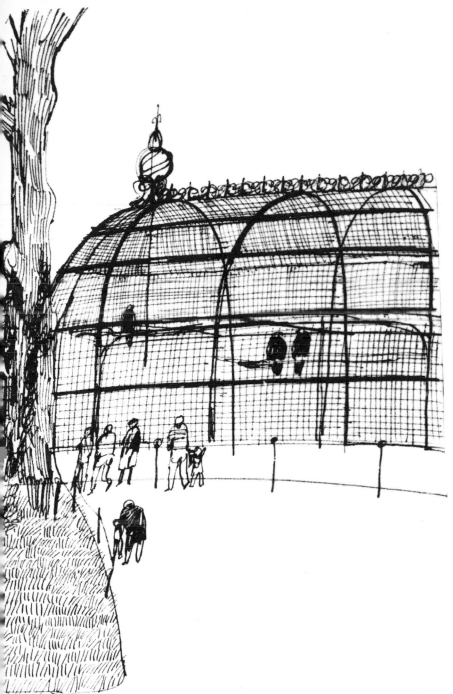

The Eagle Cage, Bronx Zoo, New York City, 1963. *A good drawing is sometimes done when you are in the lowest spirits. Arriving at the Bronx Zoo one dismal winter afternoon, I felt more like seeing that extra special movie at the Museum of Modern Art than being where I was. I wandered behind fathers leading small sons who gazed with minimal interest at the wildlife on the other side of the densely woven cages. Then I saw the massive lineality of the eagle cage, which gave me a completely fresh conception of how I could draw the zoo. I selected a Gillot 404 nib and a Spencerian school nib, Higgins India ink, and Saunders paper. From Brendan Behan's New York, 1964. Courtesy, Hutchinson Publishing Group, London, and Bernard Geis Associates, New York.*

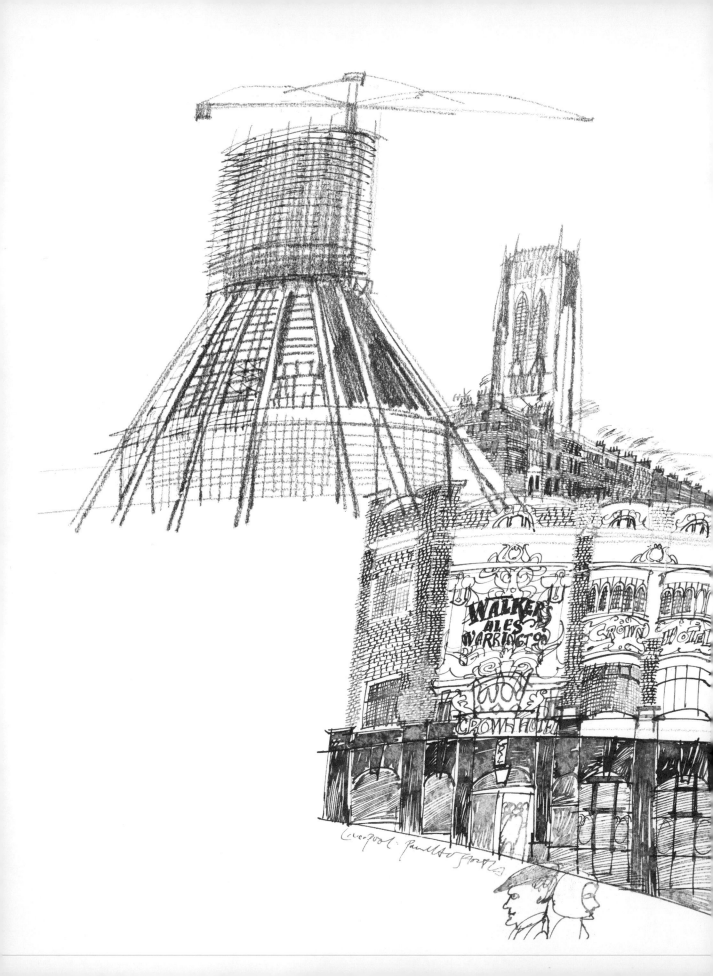

4/Drawing with reeds and quills

During the Middle Ages and the Renaissance, no drawing instruments were so readily available as reeds and quills. In those days, there were few artists who did not make drawings with reed or quill pens, or combine both with brush and various kinds of ink. Rembrandt was an obvious example; he made many superb studies with such media. In our own time, Van Gogh used reed and quill pens with a lively, searching mastery, as did Grosz, Kokoschka, Matisse, and Nolde.

Today, most artists have become so used to working with manufactured tools and materials that making *their own* seldom seems either desirable or even necessary. Yet this lack of effort denies many draughtsman the unique experience of working with an ink medium which permits a very personal approach. Drawing with reeds and quills has always given me something of the sensation of sailing a boat—an odd feeling that you are working *with* nature and not imposing yourself *on* it.

The traditional pens used by the old masters fall mainly into two types: *reed* pens, cut from the stems of cane-like grasses of various thicknesses; and *quill* pens, cut from the wing feathers of fowl and birds.

Reeds

Pens cut from reeds from the Near and Middle East, as well as from Europe, were the tools which made ink drawing on paper an art. They have long since fallen into disuse, as they were found far too limited for the requirements of detailed, realistic drawing. Unlike the steel or quill pen—both of which are flexible and responsive under almost any circumstances—a reed pen handles like a stick, its stroke being both blunt and coarse. Yet these drawbacks are compensated for by the reed's capacity to make bold line drawings, particularly on absorbent papers.

There are many types of reed. They may have short or long stems, thick or thin, with more or less pith. The type that is common to western Europe, and the one most used by the old masters, is the common reed which is yellowish brown in color. Those found in the United States are usually green and turn yellow when dry.

Building the New Roman Catholic Cathedral, Liverpool, England, 1965. *A goose quill proved itself an effective counterpoint to graphite in making this contrast between the early Victorian character of downtown Liverpool and the urgent, rocket launching platform of the new Roman Catholic Cathedral. Drawn in an 11" x 14" sketchbook of two-ply, medium surface Strathmore drawing paper.*

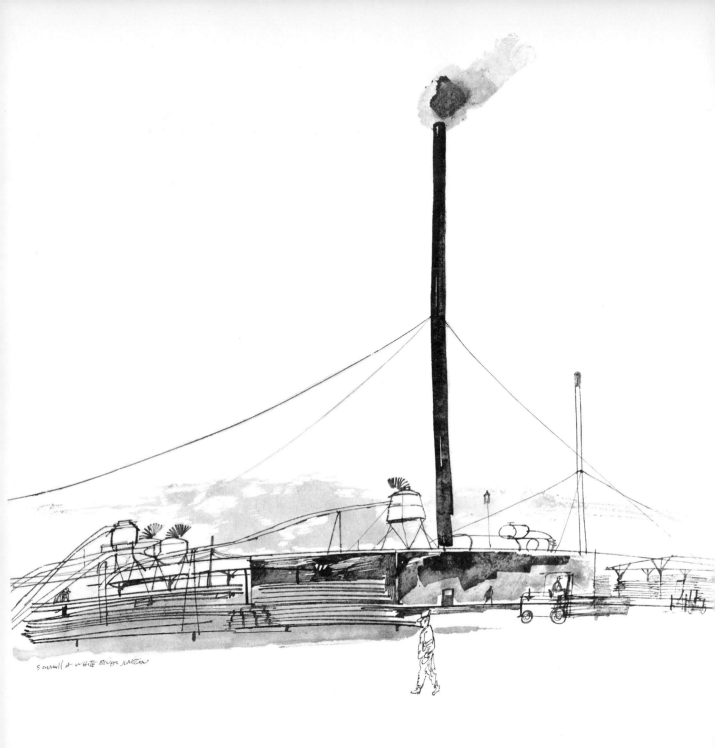

Sawmill at White River Junction, Vermont, 1963. *For an industrial drawing of this kind, bamboo pen works particularly well with washes of diluted and undiluted ink. Drawn with Higgins manuscript ink on Saunders paper. Courtesy, Fortune Magazine. Copyright, December, 1963, Time, Inc.*

In Britain, France, Germany, Holland, and Italy, as in the United States, the common reed can be obtained from the banks of marshes, rivers, canals, and lakes. The reeds grow in clusters, ranging in height from four to nine feet. A single cluster will average between thirty and fifty stems — more than enough to supply one artist for quite a long time.

You will find, however, that a reed pen tends to absorb ink rapidly. A reed is a soft, fibrous material, after all, and the ink is inclined to soak into the fibers. As a consequence, do not expect to produce lines of any length. A drawing made with a reed pen is composed of short, deftly drawn lines.

Quills

Quill pens were first used in illuminated medieval manuscripts where the precise requirements of calligraphy and miniature illustration had to be met by a finer and more responsive line than you can get with a reed.

A well cut quill pen is so responsive that pressure is seldom needed. It will glide over the surface of the paper, responding to the slightest touch. There is none of the scratching or scoring common to many steel pens. Because of this sensitivity, it is advisable to practice with a quill before you draw with it. Besides being the most sensitive, the quill is also the most versatile of pens. Quills can be cut blunt, medium, fine, or at an angle, to form a chisel-like nib. All these variations give immense variety of lineal expression.

Its somewhat fragile point, however, does not make the quill a very suitable medium for large or quick drawings. The finely cut nib is seldom able to withstand the same amount of pressure as a steel nib. Unless you are working indoors, re-cutting a quill is either inconvenient or just impossible. But I have found a quill ideal for making small drawings or illustrations of an intimate, written nature, or for adding details to a large drawing carried out in chalk, washes of watercolor, or ink.

Cutting a Reed Pen

You will need a surgical scalpel or a pocket knife with a strong blade — a thin blade is easily broken — and two sharpening stones: India (coarse) and Turkey (fine). Use a thin lubricating oil on the stones. Keep the knife very sharp by grinding it on the *right* side of the blade and tapering it to a point. A thick oblong or square piece of hardboard is also required for use as a cutting slab.

Ready-made pens, cut from bamboos or canes, are obtainable from most artists' supply stores. The type with thick barrels is the best. Or you can make a thinner type from Japanese flower canes. These are inexpensive and available from garden supply stores; with practice you can make them into excellent drawing pens — which you can do with most varieties of the common reed.

Reeds should be picked in the late summer when they have grown to their maximum height. Dry them out for at least four weeks before cutting.

Step 1. Cut the stem to the length you require. 8″ is a good length. Be sure to cut *between* the joints.

Step 2. Remove any pith in the hollow of the stem or barrel with a length of thick wire.

Step 3. Cut off one end obliquely, about 2″ up the stem.

Step 4. Make a second cut, leaving ½″ step.

Step 5. Shave away the soft inside with the knife laid flat against it. Leave the hard outer shell.

Step 6. Examine your pen from the side and from underneath, checking against the illustrations to see if it is correct.

Step 7. Drill a small hole as an ink well. This helps hold the ink, but is not essential.

Step 8. With the point of the knife, make a slit 3/4″ long from the drilled hole (if any) to the end of the nib.

Step 9. Lay the nib, back up, on the slab and cut it at the angle you require. Practice will determine your choice of nib: pointed, angled, or square.

Cutting a Quill Pen

You will need a surgical scalpel or a pocket knife; both coarse and fine sharpening stones to keep the knife very sharp and tapered; a magnifying glass to check the trueness of the quill nib; and a thick square of white glass to use as a cutting slab.

Goose or turkey quills are most common and easily obtainable from poultry or produce companies. You will have to process these yourself before cutting; those obtained from artists' supply stores have already been commercially processed. When drawn from the bird, the quill bears a membrane which must be scraped or, better still, shrivelled by immersing in a pan of sand and heating to 140° F. This procedure also hardens the quill and makes it more suitable for use as a pen. Use only the largest and strongest feathers.

Step 1. Cut down the quill to 7″ or 8″ in length. A long feather gets in the way.

Step 2. Strip the barbs or filaments of feather off the shaft all the way, *or,* if you prefer, for 3″ of the shaft. The quill is now ready for cutting.

Step 3. Turn up the barrel and make a sloping cut 1″ from the end at an oblique angle.

Step 4. Make a second cut, ½″ from the end, at a more oblique angle.

Step 5. To slit the pen, make a short cut ¼″ up the center of the barrel back. Increase the length of the slit by holding the quill firmly in your left hand. Place your thumbnail against the back of the barrel 3/8″ from the end. Push the handle of a small brush

Cutting a Reed Pen

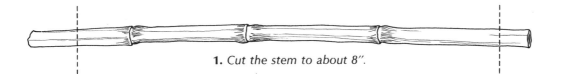

1. *Cut the stem to about 8".*

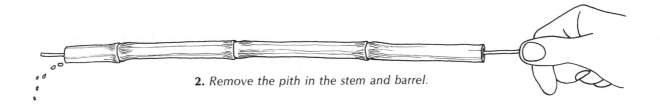

2. *Remove the pith in the stem and barrel.*

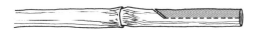

3. *Make a cut 2" up the stem.*

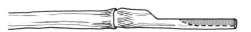

4. *Make a second cut, leaving ⅛" step.*

5. *Shave away the soft inside and pare the nibs.*

6. *The Pen should now look like this. Side. Underneath.*

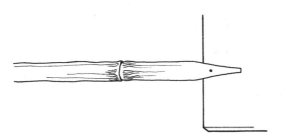

7. *Drill a small hole for an ink well.*

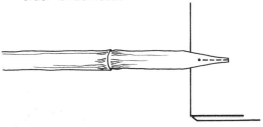

8. *Make a slit ¾" from the hole to the end of the nib.*

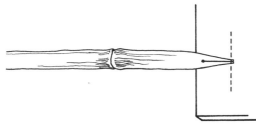

9. *Cut the nib pointed, square, or angled.*

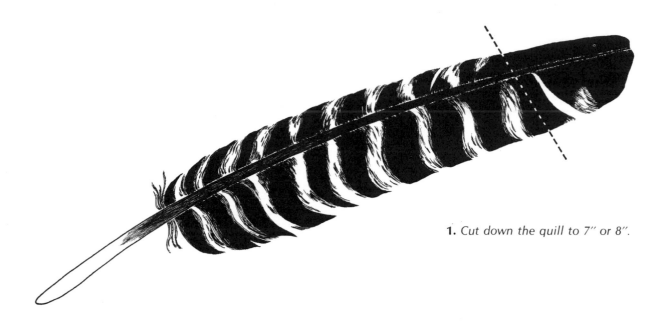

1. *Cut down the quill to 7″ or 8″.*

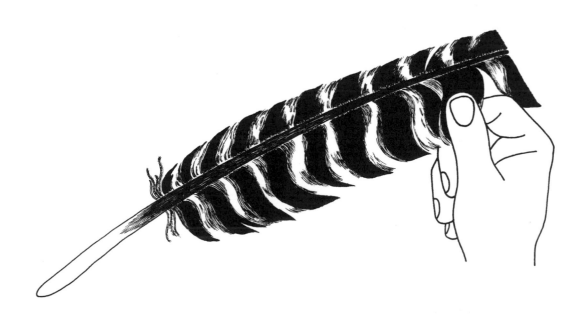

2. *Strip the barbs or filaments of feathers off the shaft.*

3. *Make a sloping cut 1″ from the end.*

4. *Make a second cut ½″ from the end.*

5. *Make a short cut ¼″ up the center of the back.*

6. *Pare the shoulders and nibs to form a point.*

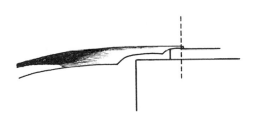

7. *On a glass slab, cut off the nib at a right angle.*

8. *Re-cut uneven or blunt nibs.*

9. *When the nibs are aligned, the pen is ready to use.*

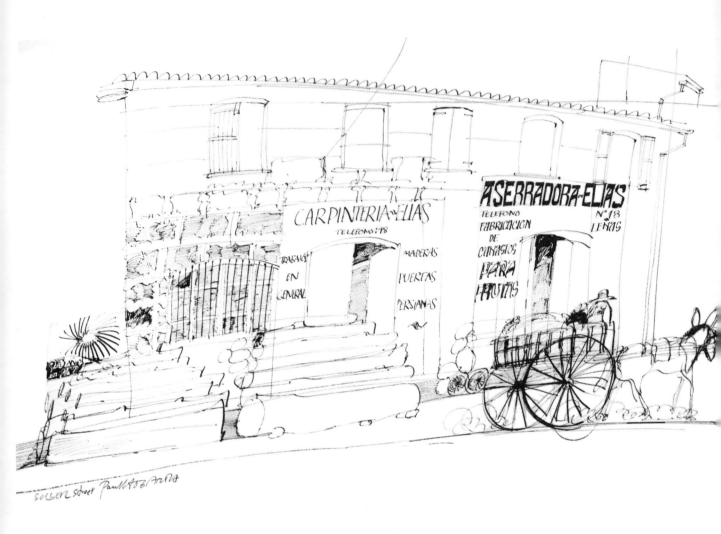

Street in Soller, Majorca, 1963. *Drawn on Saunders paper with a Japanese bamboo pen and Higgins manuscript ink. From Majorca Observed, 1965. Courtesy, Cassell and Company, London; and Doubleday and Company, New York.*

inside the quill, forcing the slit open with an upward movement. This movement will split the barrel back to the point where your left thumbnail is pressed.

Step 6. Pare the shoulders and nibs to form a point.

Step 7. Lay the nib, back up, on the glass slab and cut off the tip at a right angle.

Step 8. Examine the nib with the magnifying glass to check that the ends of the two half nibs are truly aligned. Uneven or blunt nibs must then be carefully re-cut. Sand-paper may be used to make a finer point on the nib. Draw the nib lightly over the sandpaper, on one side, and then on the other. Test the pen with ink, using light pressure. If the ink flows unevenly, the nibs require re-paring. If the nibs splay at the split while cutting or after use, turn the pen on its back and re-cut.

Step 9. The nibs are now correct; the pen is ready to use. Quills take more practice to cut properly than reeds. Do not despair if your early efforts fail. Keep at it and you will be pleased with this superb drawing tool, which has been tailor-made to fit your own way of drawing.

Using a Reed Pen on Location

On those welcome occasions when I have all the time I need to work at a more leisurely pace, I use a variety of means to do so. Whether these means include drawing with a reed pen or a quill pen depends on the content, as well as the kind of subject I have in mind.

At times, I can be guided by the precedent of a half-remembered master drawing, which I have been subconsciously endeavoring to emulate for a long time. Or I may just go ahead and make the drawing, without any clearly realized image—only the prospect in my head of spontaneously discovering an image. My approach is often a mixture of both.

One Sunday morning, I was looking for material to draw on New York's Bowery. From the doorway of a store, I watched the muted camaraderie of men who seemed like the survivors of a distant catastrophe as they stood or sat or wandered down the vista of a silent Third Avenue.

On this occasion, I think my decision to make the drawing with a reed pen had much to do with the faces of these down-and-out men, which were pitted with short, deep lines; but my decision was equally influenced by the eerily quiet atmosphere of the Bowery itself. And I wanted the white space of the paper to play as important a part as the strokes of the pen.

Then I found I had left my sketchbook behind. All I had were 20″ x 16″ sheets of Saunders paper clipped to a piece of hardboard—hardly the right equipment for making a discrete on-the-spot drawing. There could not be a more blatant example of the curious artist at work, an impression that I wanted to avoid at all costs! But by working through the side window of the store, I discovered a way to avoid offending the feelings of the unfortunate subjects of my drawing. In this way, I could see the street, yet not be seen.

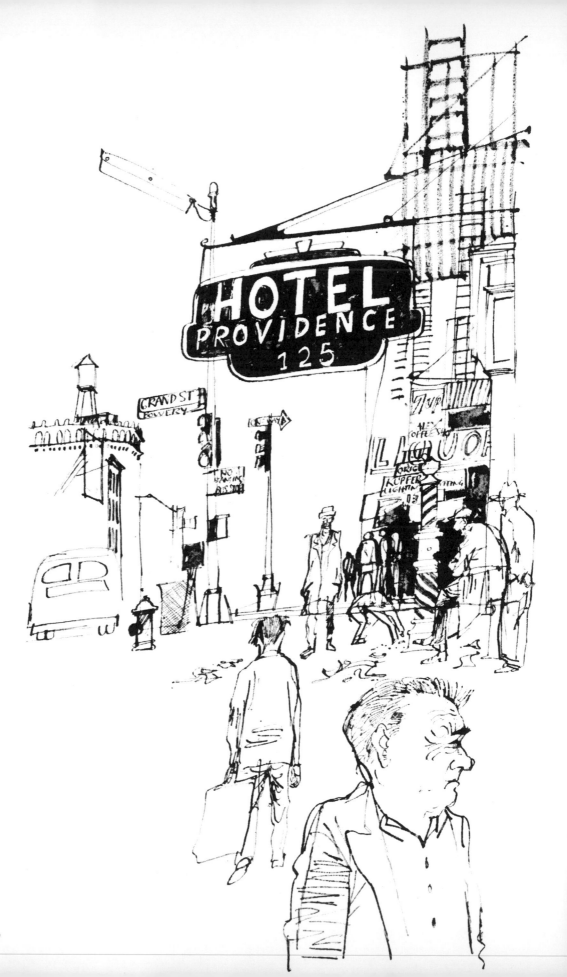

The reed pen (Japanese bamboo) did not permit me to draw lines of any great length, but its blunt, staccato strokes gave a peculiar variation to my own technique, which I needed to more aptly express my reaction to a morning on the Bowery.

Using a Quill Pen on Location

I use quills chiefly for studio work — to make small or medium size drawings for books and magazines. I have also used them on location. One such drawing was made on an icy winter day in New York City. Clutching a 20" x 16" portfolio of Saunders paper and a zippered pouch containing a Japanese brush, a small goose quill pen, and a plastic bottle of thinned Higgins India Ink, I gratefully eased myself into the convivial warmth of McSorley's Bar on East Seventh Street.

It seemed like home after an afternoon of pounding the streets of Manhattan. Often bars are like that. They can be bases and oases for itinerant artists. I looked around with interest. I knew about the place from the paintings and drawings of John Sloan long before I visited America. It was a favorite haunt of the Ashcan painters in the years before World War I. On the floor, caked sawdust. On the walls, the memorabilia of countless bygone convivialities. All this imagery called for the sympathy of a man-made rather than a machine-made drawing tool, one that would be flexible enough to trace the epithets of past and present from the walls of the room ("Make your ale a double, and save yourself a dime.")

It was early, so I found a vantage point where I could see everything as the place filled up. In this way, I was part of the place — which was fine, for I could work without being disturbed. I ordered a mug of ale, some onion rings, and fresh homemade bread, and I set to work.

Starting with the background, I worked alternately with the quill and the Japanese brush. The figures were added later. Take a close look at the drawing and you will see what I mean when I refer to the quill as a writing and drawing instrument. I can catch this written quality only with the gliding subtlety of the quill pen.

Morning on the Bowery, New York City, 1962. *Like the survivors of some obscure catastrophe, the men of the Bowery struggle to adjust to the light of another day. Drawn on Saunders paper with a Japanese bamboo pen in Higgins India ink, with touches of dry brushwork. From* Brendan Behan's New York, *1964. Courtesy, Hutchinson Publishing Group, London, and Bernard Geis Associates, New York.*

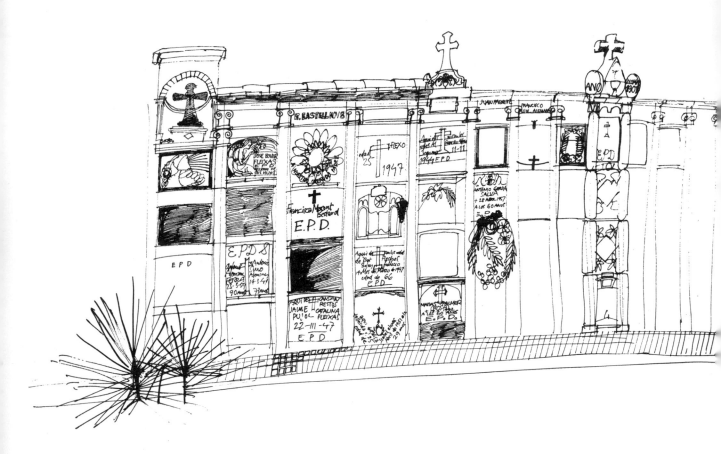

Majorcan Cemetery, 1964. *(Above) Mediterranean cemeteries are like family albums. This one at Andraitx was drawn on Saunders paper with a turkey quill in Higgins India ink. From Majorca Observed, 1965. Courtesy, Hutchinson Publishing Group, London, and Doubleday and Company, New York.*

Drug Store, New York City, 1962. *(Right) This East Side drug store called for precise delineation of its signs, ads, and exhortations. Drawn with a ready-cut goose quill and Japanese brush in Higgins India manuscript ink on Saunders paper. From Brendan Behan's New York, 1964. Courtesy, Hutchinson Publishing Group, London, and Bernard Geis Associates, New York.*

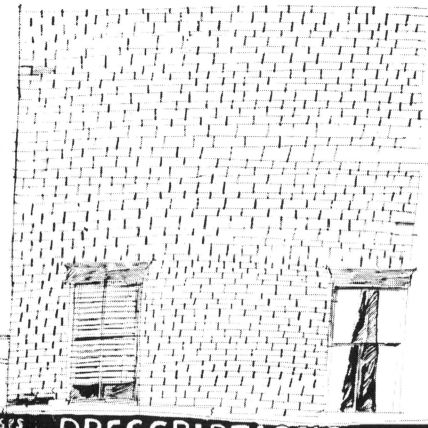

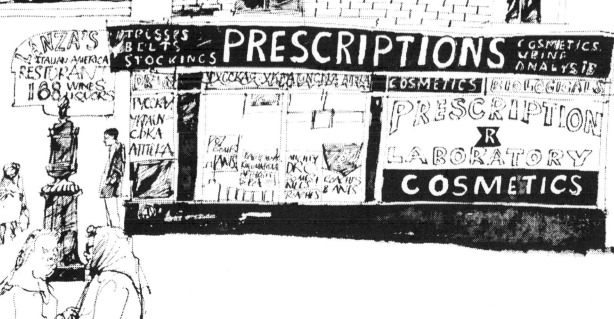

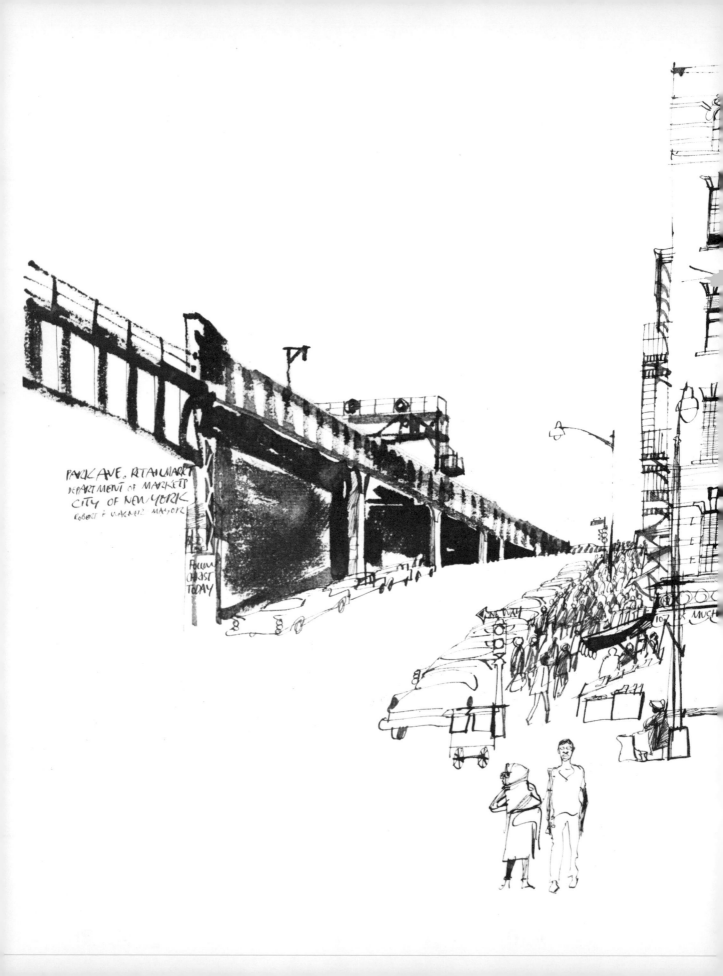

116th Street, New York City, 1962. *A simply stated composition whose effectiveness relies on a contrast of brush and line. Drawn with a reed pen and Japanese brush in Higgins India ink on Saunders paper.* From Brendan Behan's New York, *1964. Courtesy, Hutchinson Publishing Group, London, and Bernard Geis Associates, New York.*

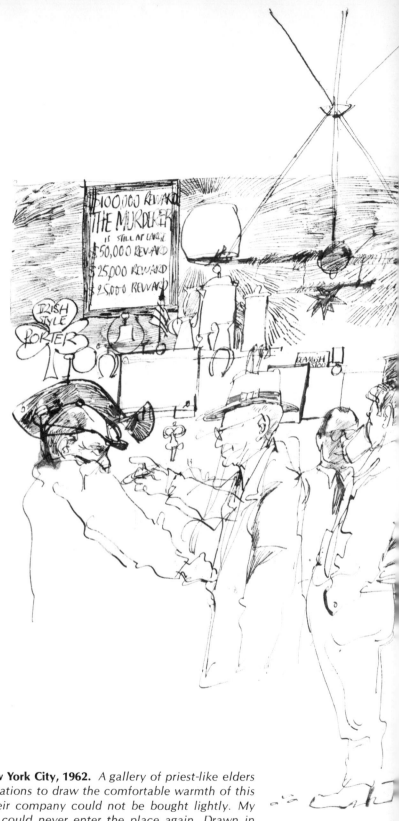

McSorley's Bar, East 7th Street, New York City, 1962. *A gallery of priest-like elders gazed impassively as I made preparations to draw the comfortable warmth of this old Irish alehouse. I knew that their company could not be bought lightly. My drawing had to be done well or I could never enter the place again. Drawn in thinned Higgins India ink with a goose quill and Japanese brush on Saunders paper. From Brendan Behan's New York, 1964. Courtesy, Hutchinson Publishing Group, London, and Bernard Geis Associates, New York.*

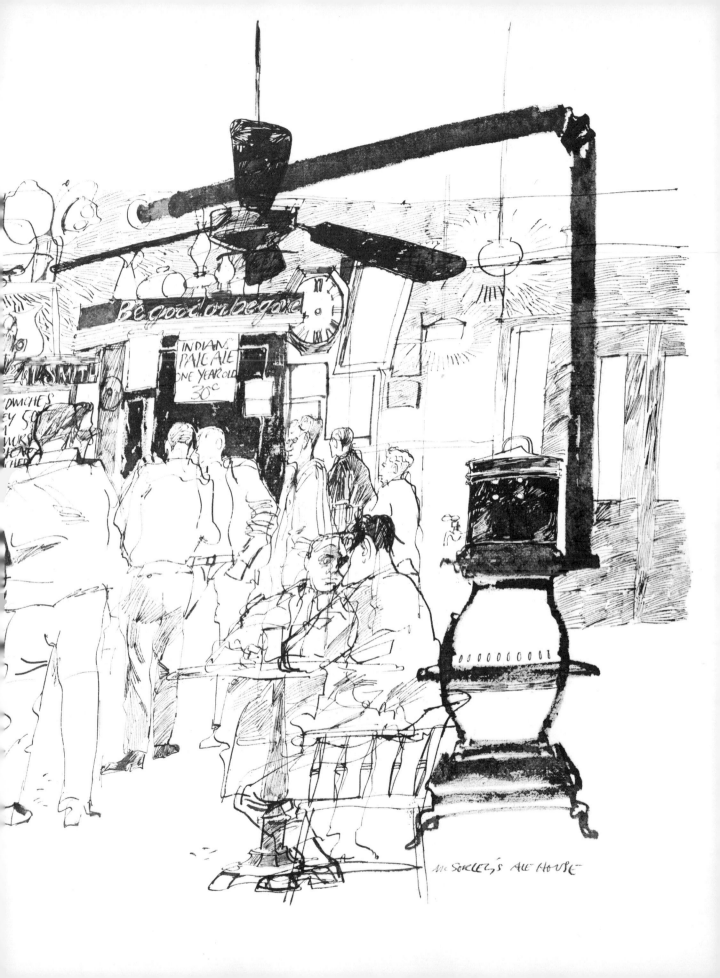

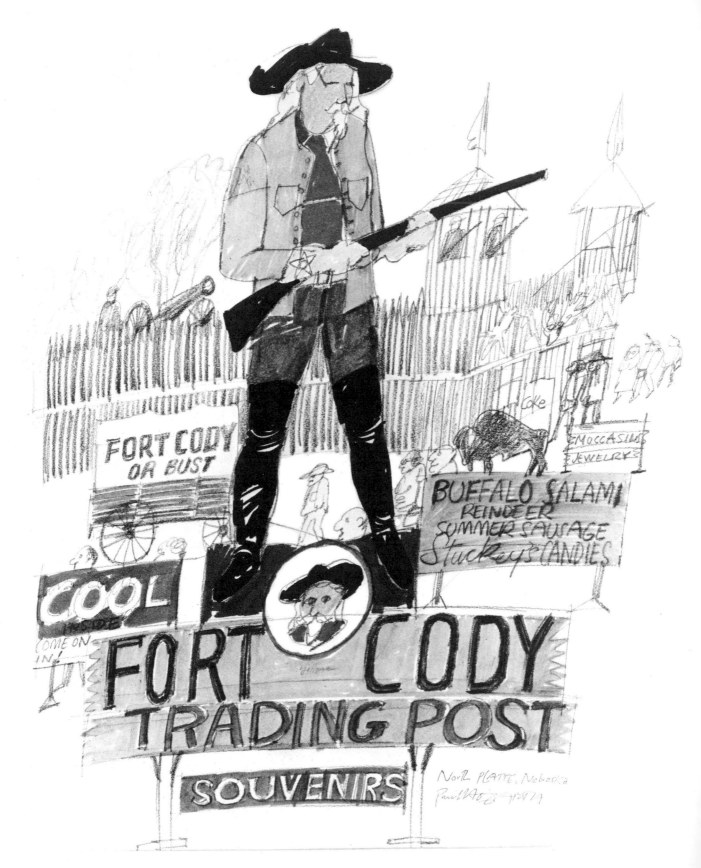

5/Felt and fiber tips

During the late 1950s, a fat, cigar-shaped aluminum pen made its appearance in artists' supply stores. It looked like a king-size fountain pen, but had a broad felt tip instead of a metal nib. The special ink it used gave off a pungent odor and dried instantly. The Flomaster had arrived.

Artists tried out the new pen with great interest. It was useful for cartoonists, set designers, and fashion illustrators, but presented certain drawbacks as an instrument for drawing and illustration. Its line, like that of the Magic Markers—which appeared at about the same time—was thick and difficult to control. The ink used in all these markers (really a dye) bled disconcertingly through most drawing papers. Nevertheless, the marker was a revolutionary instrument of ink drawing—but one that required perfecting. It was not, at this time, a medium I felt I could work with.

Discovering Markers

Necessity can sometimes change your mind. And if I might digress, this is how it happened. In the autumn of 1965, I found myself in the American northwest, drawing modern aspects of western life. To sharpen the contrast with the Old West, I followed the western itinerary of the famed nineteenth century English artist-reporter, Arthur Boyd Houghton. His western drawings were the best of a series on American life which appeared in the London weekly Graphic in the 1870s.

The intrepid Victorian artist reached the plains of Nebraska after days of arduous travel from New York by riverboat and railroad. I took the dawn jet from New York via Chicago to Omaha: flying time, three hours. While it was still morning, I rented a big red Chevrolet; by early afternoon I was speeding on U.S. Route 80 by the Platte River toward Minden, Nebraska, en route to the Black Hills and the Badlands of the Dakotas. I had three weeks to make my drawings, and I was driving an automobile; Houghton, who had several weeks, worked between side trips as he rode in a railroad car.

Like Houghton, I found plenty of material. The West has not changed in that sense! My first subject was a giant, colorful billboard announcing Harold Warp's Pioneer

Fort Cody, North Platte, Nebraska, 1965. *A pop Western present mixes with an authentic Western past. Drawn in an 11" x 14" sketchbook of one-ply, medium surface Strathmore Alexis drawing paper with Faber Markettes and a 6B Faber pencil. Courtesy, The Strathmore Paper Company, West Springfield, Massachusetts.*

Village at Minden. Watercolor was out of the question—I did not have enough time—and there were other drawings to be made. But I wanted to get the colors right. I decided to use the Faber Markettes I had slipped into my bag.

I had discovered these in a New York artists' supply store and found felt-tipped pens and markers *much* improved. The new Flomasters and Markettes could be rubbed and worked on with other inks and other media. It was also possible to obtain extra color effects by working with one color on another, as with watercolor. The inks— even if spirit-based—did not bleed through nonabsorbent papers quite so much. A water-based ink did not bleed at all. There was also a wide choice of tips—fine, thick, narrow, broad, pointed, and chisel—with which any thickness of line was therefore possible. They might be just what I needed to overcome my infuriating inhibition about using color.

Working quickly with the markers, I enjoyed the sensation of drawing with what seemed to be a pen and a brush in one. Although this particular drawing did not work out as well as I had hoped, I looked forward to making others and mastering the use of markers. There were, I discovered, many ways to use them: I could work more as a painter does, drawing or painting the larger shapes directly in two, three, or more colors, then working on these with a 6B graphite pencil, an ink wash, or a brush line. Or I could make an outline drawing in pencil or brush, and *then* fill in with color.

Advantages of Markers

On assignments which took me to Morocco, Tunisia, and Libya in 1966, and to Russia in 1967, I discovered more ways of using markers. By this time, Faber had introduced an improved version of their Permapoint Markette, which was called the Design Markette, available in forty-eight colors, with pointed or chisel-shaped nibs. So great was the color range that I found I could work almost like a painter!

Provided that the markers are high quality, they can be adapted to almost every kind of drawing. I find them particularly good for making large and elaborate draw-ings in full color of historical or exotic architecture—the sort of subject I would once have avoided because it would have required using the time consuming medium of watercolor. Now, with markers, I can take on a big subject because I can reduce the drawing time to an hour or two.

Time savers are very important to me when I travel. I am constantly on the move,

Oued Bouial Kabilat Soukanat, Morocco, 1966. *Never neglect drawing what you feel may be good material. I was driving at great speed from Marrakesh to Fez, trying to make up for the time I lost waiting for a torrential rainstorm to subside. Then I entered a lunar wilderness of the Haouz Plain in the Middle Atlas, and wondered at the strange, fort-like farmsteads with fences of sagebrush. Loath as I was to stop and do so, I had to make something of this scene! I created the lunar atmosphere by first working in graphite pencil which I fixed with Rowney Perfix. Then I blotted successive watercolor washes on which I worked with Faber Markettes and a Spencerian school nib in a 20" x 16" sketchbook of Daler cart-ridge paper. Courtesy,* Weekend Telegraph, *London.*

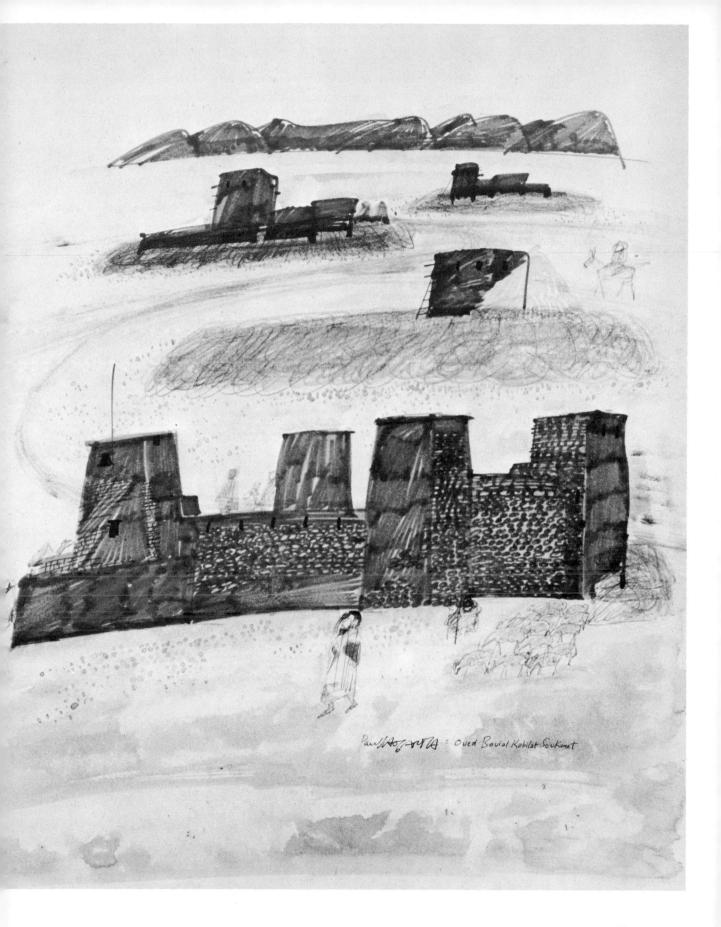

Paul HOGARTH : Oued Bouial Kabilat Soukinet

generally seeing more dull places than fascinating ones. When I spot a subject I desperately want to draw, I generally have little time left to spend working on it.

Such was my experience in Russia. At the end of my trip, I discovered Suzdal, the ancient medieval capital of Muscovy. I had but two days to work in this town which offered enough material for two months' concentrated work! The huge architectural ensembles — like the Pokrovsky Monastery which Ivan the Terrible liked to visit when he was in trouble, and the Spas-Efimovsky Monastery which housed the political prison founded by Catherine the Great — presented way-out imagery which defied my summary portrayal. Yet I found I could tackle such challenging subjects with felt-tipped markers.

Techniques Appropriate to Markers

Whether you can use markers effectively depends on your particular approach to drawing. Markers can be used simply and boldly to fill in shapes delineated by a fiber-tip marker, a fountain pen, or any other kind of pen; or they can be manipulated to create a wider range of elaborate techniques by using one color over another. They can also be combined with other media such as graphite pencils and diluted washes of ink or watercolor.

The subject you choose also determines how and when you will use color markers. Pop city subjects, such as billboards, are best drawn directly on the paper with color markers, then drawn over with a pen or graphite pencil. Historical subjects, on the other hand, call for a combination of colors superimposed one over the other. By this technique, frequently complex textural qualities can be effectively intensified. In drawing *The Spas-Efimovsky Monastery, Suzdal,* for instance, I used a bright yellow marker to fill in the area of the gateway and walls, then worked over this area with brown, purple, and black markers. I later added washes of ink and watercolor to enrich the effect still more.

Fiber Tips

As plastics replaced wood and metal for the manufacture of an increasing variety of drawing tools and equipment, a new fiber-tipped ink drawing pen appeared that drew a line that was something between a brush and a ballpoint.

Even the early models were good enough to work with, but these seemed unyielding and insensitive compared with the surprisingly flexible and sympathetic fiber tips now available. Improved Pentels (the Pentel D), the Faber-Castell Presto, the Esterbrook Color Pen, the Eagle Tip, and the Permanent-Ink Illustrator are remarkable ink drawing pens for making almost any kind of drawing on any kind of paper. I find them just as useful for making large, elaborate drawings as I do for small sketches in pocket-size sketchbooks.

Felt and fiber tips encourage a much more informal attitude regarding the use of color in drawings, and should be an important part of a modern draughtsman's armory of graphic media.

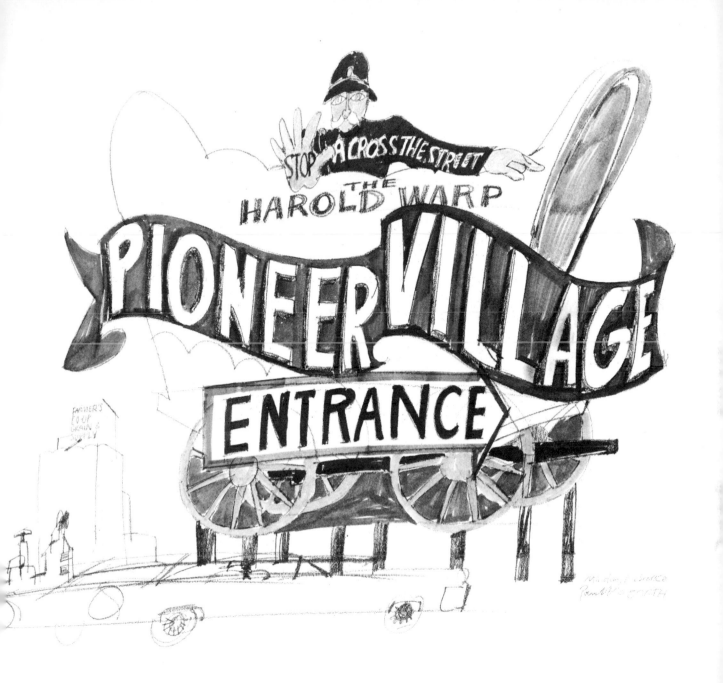

Pioneer Village, Minden, Nebraska, 1965. *Every weekend, the old folks and their grandchildren crowd into the cluster of Trading Post, House of Yesterday, Automobile Museum, and Indian Stockade known as Pioneer Village. Before I had a look around, I made this rapid drawing in an 11″ x 14″ sketchbook of one-ply, medium surface Strathmore Alexis drawing paper, with Faber Markettes and a 6B Faber pencil. Courtesy, The Strathmore Paper Company, West Springfield, Massachusetts.*

One Word of Warning

Felt and fiber tip pens fascinate observers abroad, in countries where such pens are unknown. If you are not vigilant, your markers may disappear one by one. If you carry only one box with you, the mysterious depletion of its contents may put a stop to your work.

I had the unfortunate experience of losing an entire box of treasured markers to a boy in Samarkand, who regarded these markers as truly magic. Foolishly I had told him and his friends that markers gave one the power to draw well! This event occurred during the second week of a two month visit to Russia, where color markers are unobtainable. I realized I had to try somehow to retrieve the lost box of markers. I frantically blotted the watercolor on which I had been working, packed up my things, and vigorously began to pursue the purloiner. I was urged on by a horde of laughing children, but it was no use. Today, somewhere in Samarkand, a nine-year-old boy is happily drawing with my box of Faber Design Markettes. Well, good luck to him!

Holy Shrine, Fez, Morocco, 1966. *(Right) Deep in the Medina of Fez, women still pay silent tribute to the memory of a royal wife who defied the marital tyrannies of her sultan husband. Discretely drawn — as these subjects must be in a Moslem land — in a 7" x 10" Planet sketchbook of cartridge paper, with Faber Markettes, an Esterbrook fountain pen, and a 6B Faber graphite pencil. Courtesy, Weekend Telegraph, London.*

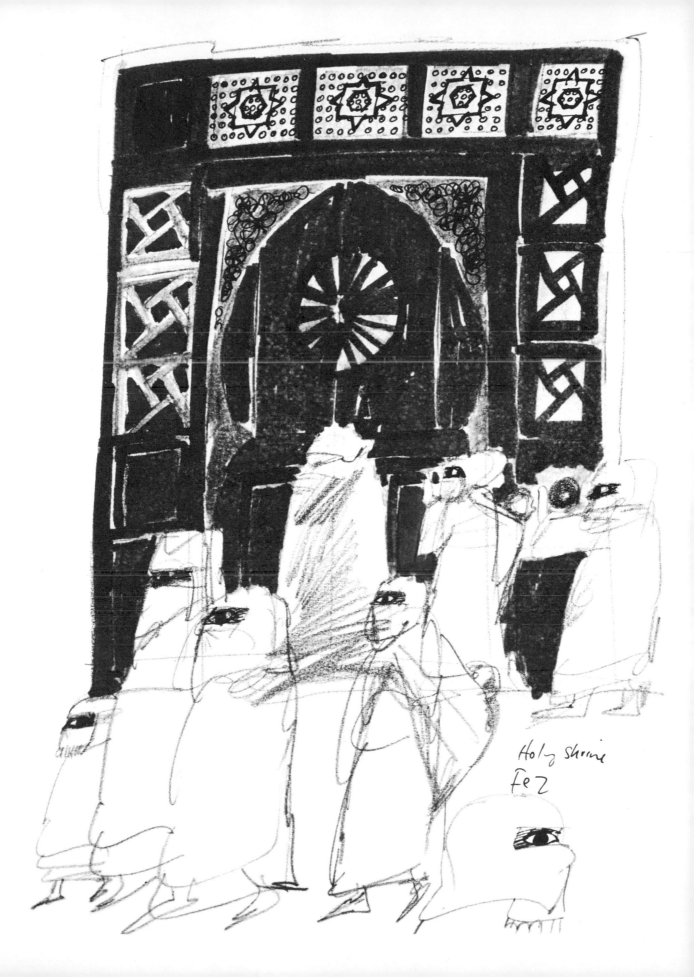

Holy shrine
feZ

6/ Brush drawing

Although this generalization certainly should not be rigidly interpreted, each of the various ink drawing media is suited to different subjects: pens for drawing figures; markers for creating images of historical and modern life; quills for literary illustration. The brush, I would say, is the best tool for drawing architecture in black-and-white — particularly the kind of structures that have taken a beating from history.

The idea of drawing with a brush occurred to me during my travels in the Far East. I often watched the street scribes manipulating their pointed bamboo brushes with enviable fluency, enlivening sheet after sheet of snow white paper with the crisp imagery of Chinese calligraphy. I brought back enough bamboo brushes to last a lifetime. But somehow I never got round to using them.

Then, almost ten years later, I took them out of mothballs to bring along on my first visit to the United States. I planned to make drawings for the book *Brendan Behan's New York.*

Discovering the Brush

The look of America, as I said earlier, had much to do with my interest in ink media. The monumentality of New York called for a big brush, loaded with jet-black ink, and for a good, strong, steel pen giving close support. How else could I depict the Franklin D. Roosevelt Drive slashing across the lineal outline of Brooklyn Bridge? I felt this even more strongly when I penetrated New England and drew its vast Victorian typewriter, piano, and organ factories along the Connecticut River Valley.

This was also true of a recent series of ink brush drawings I made of the Byzantine churches of Istanbul. It would have been difficult for me to draw them in any other way than by using blotted passages of diluted and undiluted inks to convey the aura of the past. In one of these drawings, *St. Mary Panachrantos, Istanbul, 1966,* I was able to convey in black-and-white the richly decorative fabric of Byzantine masonry, without using any color.

Via Roma, Palma, Majorca, 1963. *Built on a river bed, the Via Roma is the island's oldest promenade. Here I used a Japanese brush fully loaded with Higgins India ink from the bottle, blotting to add texture to the shape and shadow of the great plane trees. The rest of the drawing was made with a Spencerian school nib. From* Majorca Observed, *1965. Courtesy, Cassell and Company, London, and Doubleday and Company, New York.*

The brush, therefore, is particularly suitable for the kind of drawings in which you want to dramatize your subject in a stronger, more dynamic way than other ink media will allow.

Choosing Your Paper

Good quality materials are important for brush drawing. To obtain the best results from my habit of blotting washes or passages of ink, I need a fairly good paper. If I use a paper of poor quality, I run the risk of the ink drying too quickly for the blotting paper to effectively change its tone, or I helplessly watch the ink spread raggedly into the porous fibers of the paper.

Even hard, non-absorbent papers (such as Saunders Paper) are sometimes unpredictable; they are *too* hard. You can, however, allow the ink to dry a little before blotting. It is therefore a good idea to test papers before committing yourself (and your money) to them. Only if I use a good semi-absorbent paper like Strathmore Drawing, medium surface, can I really rely on my passages of diluted or undiluted ink, drawn or blotted, to turn out the way I want them to be. Moreover, paper of this quality — even when covered with an ink wash or blotted ink — retains its original working surface under all circumstances. And this is most important if you wish, as I often do, to draw on top of a wash with a quill pen or small brush.

Strathmore one-ply illustration board and Alexis drawing paper stood me in good stead during my trip to the Northwest in 1965. Because I was doing the driving as well as the drawing, I frequently had to limit my drawing sessions even in interesting places. On the occasions when I did stop, I was obliged to work extremely quickly and therefore used a fountain pen, or a brush and steel pen, with a Gillot 303 nib.

The drawing *Scout's Rest Ranch, North Platte, 1965* was made in this way. I had spent too much time looking at Buffalo Bill memorabilia and talking to the ranger in charge of the ranch, custodian George Leroy. The afternoon sun was already sinking, and I realized the mood would soon pass if I did not leave the house and begin my drawing immediately.

I started to draw the framework of the house with a Japanese brush, blotting here and there to give the strokes a textural quality. Then I filled in the wooden tiles of the roof with a Gillot 303 nib. I had just begun to draw the grass with the same pen when a visiting farmer strode by. I decided to incorporate him into my drawing and switched to a 6B Venus graphite pencil to differentiate his figure from the house. "Son," he drawled "you don't want to spoil that picture, do you?" When the drawing was complete, he remarked: "Well, I'll be durned if it isn't jest like me too — all ornery!"

Garage at Hill City, South Dakota, 1965. *Not much of the old gold mining town is left, so I settled for this vaguely 1920's garage as a piece of Black Hills memorabilia. Drawn almost entirely with a Japanese brush and a Winsor & Newton No. 6 sable on one-ply Strathmore illustration board. Courtesy, the Strathmore Paper Company, West Springfield, Massachusetts.*

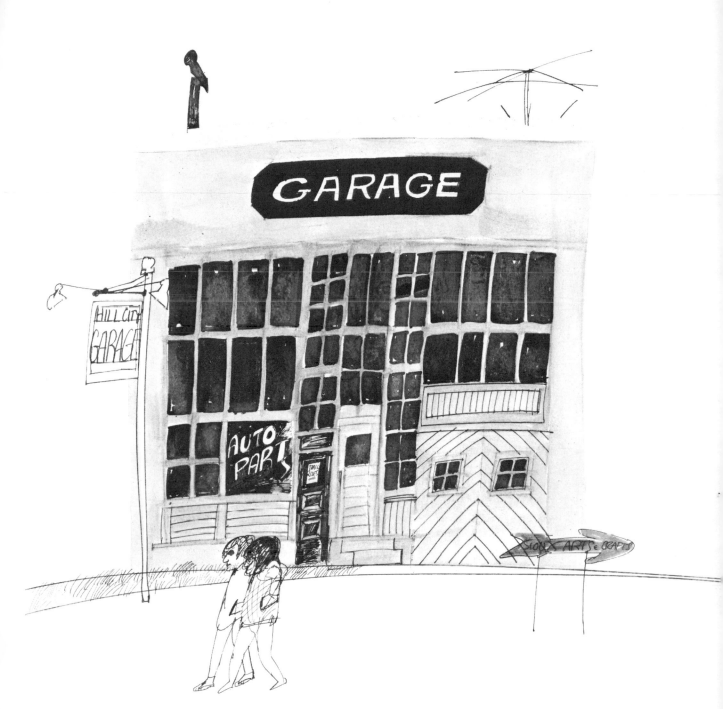

When I had stopped laughing, I finished drawing the grass in and around the farmer, leaving this area to dry for a moment before I washed it over with diluted ink. On a poor paper, this procedure would have caused a disaster, obliterating the lines instantly. The Alexis drawing paper, however, stood up to the test remarkably well.

Choosing Brushes

Brushes, too, should be carefully chosen. Like most tools, they are made according to a predetermined standard of quality or price—high, medium, or low. Sometimes a cheap brush will look very much like a more expensive one—but there will be a big difference in working qualities. It is really wise to buy one good brush rather than three cheaper ones.

To begin, you will not need more than one; a pointed Japanese brush of brown hair will give you all the variations and thicknesses of line you require. Later, if you use colored inks, you can add others: one for each primary color, and maybe a No. 00 or No. 1 sable brush for detailed work.

Old Deerfield, Connecticut, 1963. *On my way up to the mill towns of the Connecticut River Valley, I passed through this historic old village and nearly settled there. A nostalgic tribute made on white Saunders paper with a Japanese brush and a Spencerian school nib in Higgins India ink. Courtesy,* Fortune *Magazine. Copyright, December, 1963, Time, Inc.*

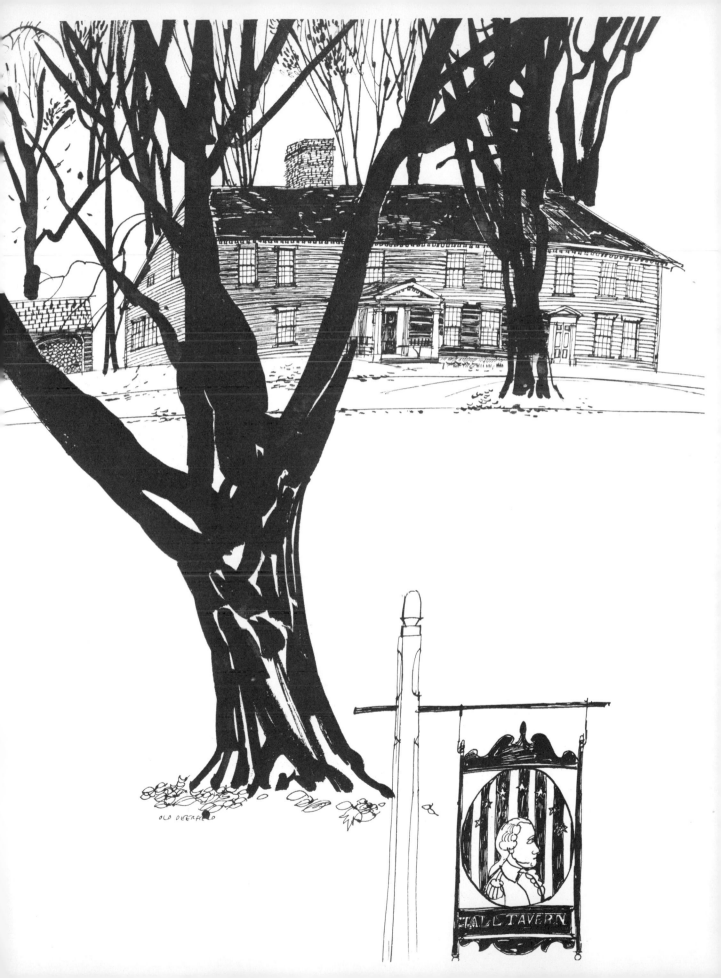

OLD DEERFIELD

HALL TAVERN

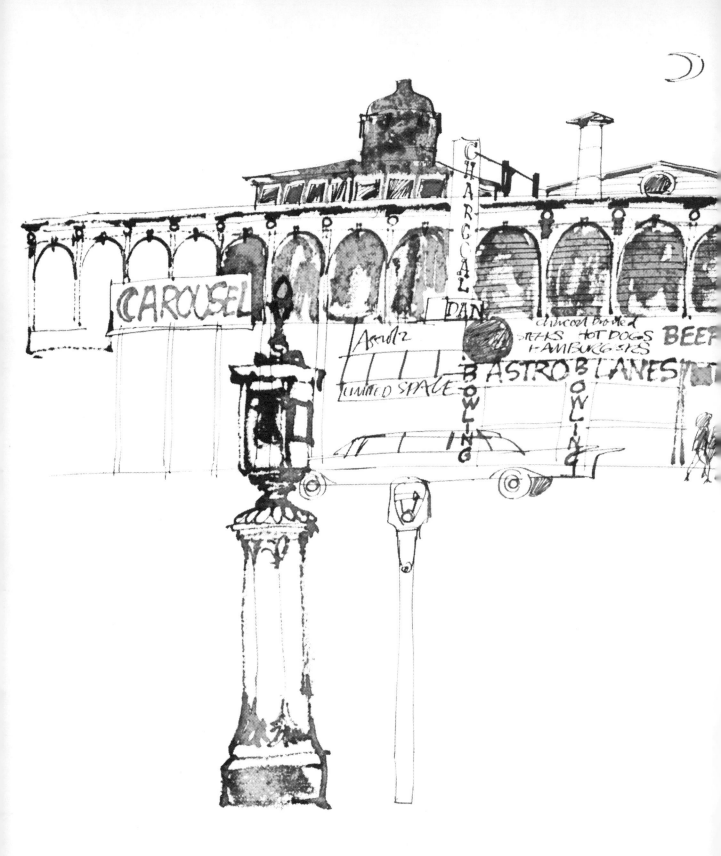

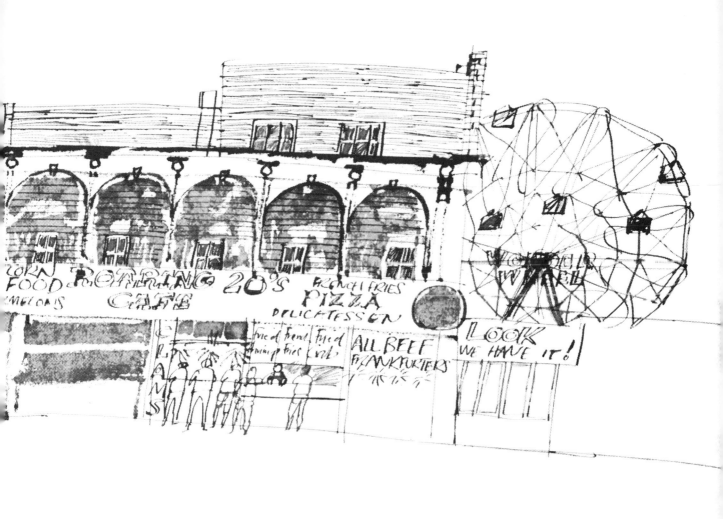

Coney Island: Winter, New York, 1962. *Out of season, the vast amusement park looks like the stage of an old theatre abandoned by its audience. Drawn on white Saunders paper with a Japanese brush and a Winsor & Newton No. 6 sable brush in Higgins India ink. A Gillot 404 nib was used for the pen line. From Brendan Behan's New York, 1964. Courtesy, Hutchinson Publishing Group, London, and Bernard Geis Associates, New York.*

Telegraph Wires, Holyoke, Massachusetts, 1963. *These telegraph wires and power lines gave off the ambiance of an old postcard in a family album sent by some emigrant uncle in the days before World War I. Drawn on white Saunders paper in Higgins India ink with a Japanese brush and a Spencerian school nib. Courtesy, Fortune Magazine. Copyright, December, 1963, Time, Inc.*

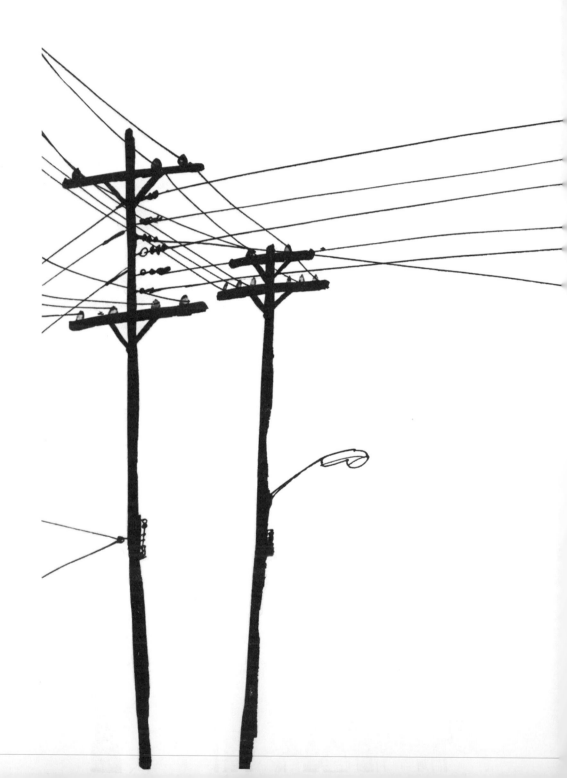

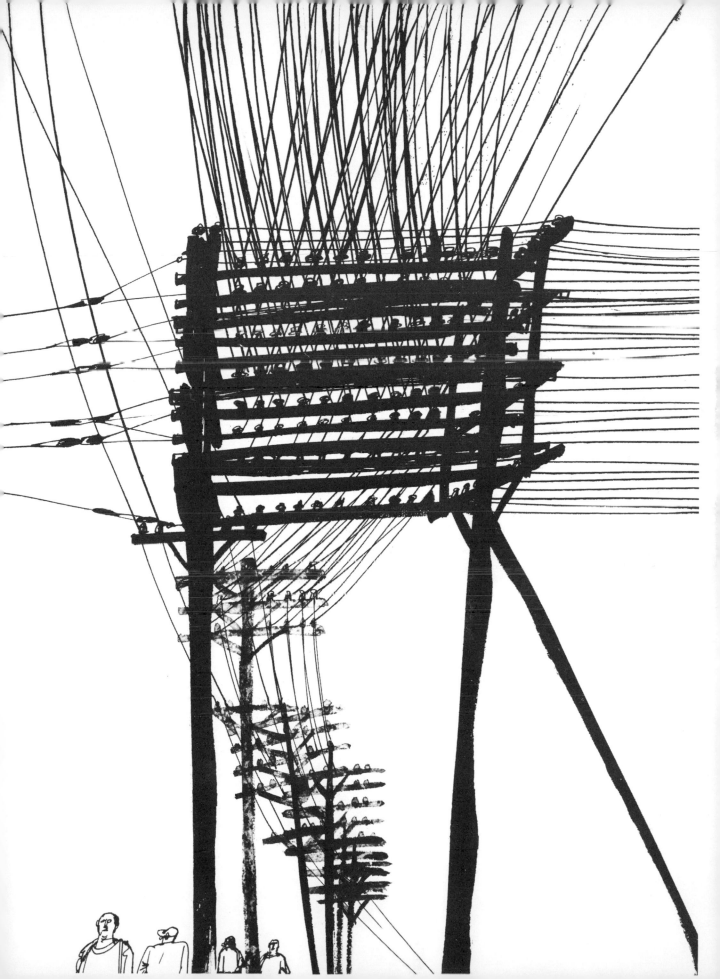

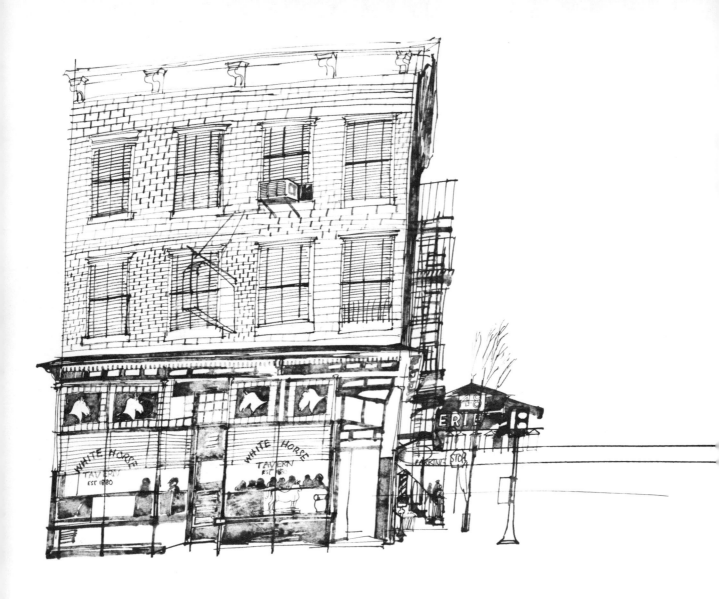

White Horse Tavern, New York City, 1962. *(Above) Dylan Thomas liked this Hudson Street bar because it resembled an old London alehouse. I liked it because its variations on the theme of model horses suggested an equine funeral parlour with undertones of a sinister saddlery business on the side. The frontage was drawn with a Winsor & Newton No. 6 sable brush and blotted Higgins India ink; the rest of the building was done with a Gillot 404 nib, all on a Strathmore Alexis layout pad. From Brendan Behan's New York, 1964. Courtesy, Hutchinson Publishing Group, London, and Bernard Geis Associates, New York.*

Art Nouveau Gravestone, Municipal Cemetery, Palma de Majorca, 1963. *(Right) The incredible variety of period ornament to be found in cemeteries make them ideal places to work in. This bizarre specimen was drawn in Higgins India ink on Daler Cartridge paper, using a Winsor & Newton No. 6 sable brush and a Gillot 303 nib. From Majorca Observed, 1965. Courtesy, Cassell and Company, London, and Doubleday and Company, New York.*

PALMA MUNICIPAL CEMETERY

Paul Hogarth

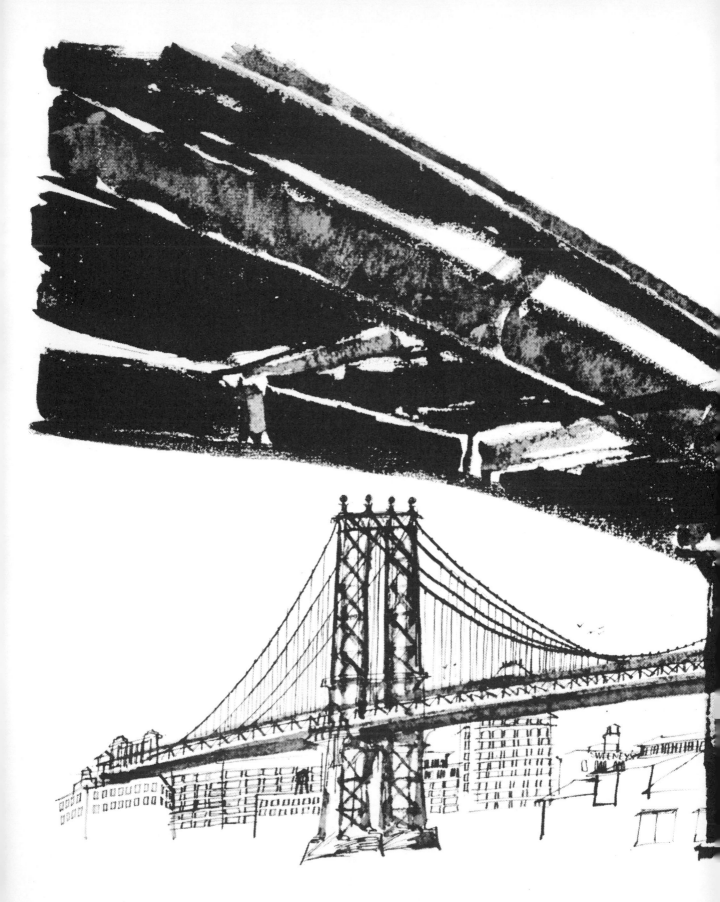

Manhattan Bridge from South Street, 1962. *The elevated railroads, suspension bridges, and expressways of New York first made me think of drawing with a brush. This bridge in lower Manhattan was drawn with a Japanese brush, fully charged and occasionally blotted. I added the buildings with a Spencerian school nib. White Saunders paper and Higgins India ink. From Brendan Behan's New York, 1964. Courtesy, Hutchinson Publishing Group, London, and Bernard Geis Associates, New York.*

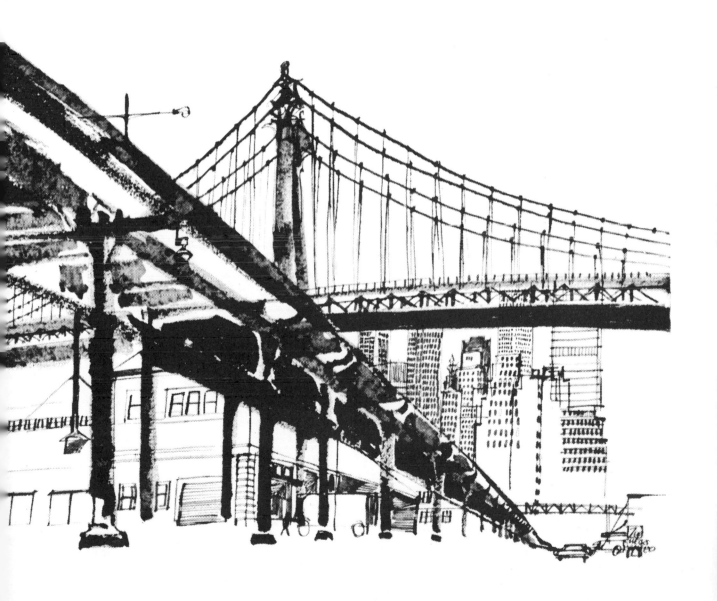

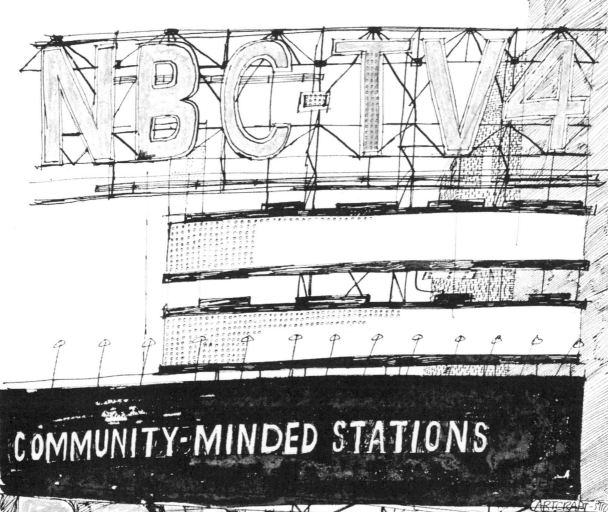

NBC-TV4

COMMUNITY-MINDED STATIONS

ARTCRAFT-STRAUSS

BOWLING LANES

ENTRANCE ENTRANCE

GLOBE

AMERICAN PREMIERE "THE FLESH IS HOT" AND "NAKED VENUS" ADULTS ONLY

WELCOME NOW OPEN TIMES SQUARE BOWLING OVER TOFFENETTI'S

THE FLESH IS HOT

ENTRANCE OPEN 24 HRS

BROADWAY

7/ Drawing with mixed media

Having worked with each of the basic media of ink drawing, you may wish to move on and combine them for more elaborate drawings. Before you do so, make sure that they will, in fact, combine.

By this I mean that they should offer a distinct contrast to each other. An obvious example is that a line drawn with a steel pen, quill, or reed combines best with diluted washes of ink or watercolor—as does a line drawn with a soft graphite or charcoal pencil. Equally effective is the combination of a thick line drawn with a felt-tipped marker and a thin one drawn with a steel pen, quill, or black ballpoint pen.

Some Black-and-White Combinations

All the media I have discussed in the preceding chapters combine well with various black or colored inks and watercolor. Remember that the essential structure of a drawing should be lineal and that any addition of washes, inks, and watercolor is really a means to increase the drawing's visual impact or enrich its imagery.

The actual combination you use will depend on subject matter and how you react to it. Be conscious of what makes you react to what you see, then try to figure the best way of translating your feelings into specific media. Architecture, for example, according to style and period, may suggest the dramatic approach of a fully loaded brush and a steel pen, or the precise handling of a well sharpened, soft graphite pencil and blotted penwork.

Before you attempt to interpret your feelings, however, get used to drawing with more than just a pen or pencil. Work with a simple combination before tackling a combination of several. A good one to start with is a brush with diluted or undiluted ink—which you can blot or allow to dry—together with a steel or quill pen. Both combine very effectively and are relatively easy to use on location. I have made many such drawings by boldly juxtaposing the lineal structure of a lumber mill, for

Broadway Signs, New York City, 1963. *A touch of color applied with chalk or pastel — if not watercolor or markers — can often boost the visual impact of those drawings which exploit the decorative potentials of a subject. This drawing of billboards, electric signs, and movie ads was drawn on white Saunders paper in Higgins India ink, with Spencerian and Gillot 290 nibs and a Japanese brush. Blue and orange chalks were then used to fill in the signs above the movie theatre. From Brendan Behan's New York, 1964. Courtesy, Hutchinson Publishing Group, London, and Bernard Geis Associates, New York.*

example, with a partial silhouette of an oddly shaped piece of industrial machinery.

An equally effective combination, more suitable for those who are more relaxed in their approach to drawing, is soft graphite pencil—or better still, charcoal pencil or Conté crayon—in conjunction with washes of diluted ink. I used this combination to make the drawing of a Moscow movie theater. Bear in mind, however, that the subject itself must be appropriate to the media you wish to combine.

Color

A basic black-and-white image is essential for a draughtsman. Once you have such an image, it can always be enhanced by adding colored inks or watercolor.

One word of warning: If you do employ such a combination based on the liberal use of black ink with color of *any* kind, make sure that the ink is waterproof. Otherwise, your ink will spread in a most disconcerting way and spoil your drawing. India ink is, of course, waterproof, as is the special ink used in the Flomaster and the spirit-based Faber Design Markettes. Lines are therefore permanent and will hold when washed over with inks, with markers of different colors, or with watercolor.

Mixed Media and Stylized Drawing

Drawing with mixed media is particularly suitable if you draw in a stylized or decorative manner. Shapes drawn with a pencil or brush, and filled with cross-hatching of pen lines or color, will give your drawing punch, texture, and movement—vital trimmings for a really successful drawing.

It took me quite some time to master the simple mixed media of black-and-white before I attempted more elaborate drawings with color. In these, I sometimes use a heavy brush line of ink backed up with passages of color drawn with markers or watercolor, together with figures outlined with a steel pen or a soft graphite pencil. I have worked with such a mixture when I have needed to emphasize a grotesque or elaborate building, where color played just as important a part as the movement of figures, taking place in the building or against it.

A Case History

Mixed media subjects rendered in color and augmented with passages of black-and-white are not as difficult to tackle as they may appear—provided that the central

The Ribat, Monastir, Tunisia, 1966. *When time is short, markers are very useful for speeding work on more elaborate drawings. This large drawing was made in an hour and a half, by using a combination of fast drying color markers, watercolor, and a 6B graphite pencil. The massive bulk of the Ribat itself was drawn directly with a yellow Faber Markette. Because the Markette dried instantly, I was immediately able to work with a Japanese brush and diluted strokes of Grumbacher raw sienna. Drawn in a 16" x 20" sketchbook of Daler cartridge paper. Courtesy,* Weekend Telegraph, *London.*

MONASTIR (TUNISIA)
Paul HOGARTH

elements of the drawing are themselves colorful. For example, in my drawing *Calle Marco Polo, Tangiers,* I mixed four ink drawing media — brush, steel pen, ballpoint, felt-tipped markers — with watercolor and graphite pencil.

I began by making a rough sketch which helped me decide where color should be distributed. I decided it should be concentrated on an old villa which had attracted me to the place in the beginning. Color could also be used in scattered spots, such as the *art nouveau* plaque, the luxuriant garden of tropical plants and trees, and the distant Mediterranean. I would link these color areas with passages of blotted ink washes, pen work, and graphite pencil to convey the fly-blown ambiance of it all.

Starting with the foreground, I washed in a blistered wall with a Japanese brush loaded with a diluted wash of Pelikan Fount India ink. I immediately blotted the wash, then added a pitted effect with the point of the Japanese brush dipped straight into the bottle of ink. I carried this textural effect still further with a steel pen. The plaque, which I was anxious to emphasize, was drawn with a Parker ballpoint pen. I chose a ballpoint rather than a steel pen because I wanted a much less defined line to contain the mauve watercolor with which I intended to fill in the letters. I then drew in the luxuriant shrubs and trees with a yellow marker and blue-green watercolor. The Villa Eugenia, rising high above the garden, was drawn with a 6B Faber graphite pencil. I used an orange marker to make the bands of decorative brickwork.

What happened next typifies my approach to drawing and explains what endears me to working on location. I felt the villa looked inexplicably lonely, so I moved further down the street to see what additional material might present itself. From the foot of the hill, I could see a spooky French office building, the Yachting Club, and the boulevard. I squeezed this material in with a graphite pencil, then moved to another position from which I painted the sea in watercolor, and added the Gibralter ferry as it moved out across the tranquil bay. Finally, I drew in the figures of a fisherman and a lonely retired Englishman.

Sultan's Palace, Fez, Morocco, 1966. *(right) In the open space between the outer and inner gates of the Sultan's Palace, scribes, jugglers, story tellers, snake charmers, fortune tellers, magicians, and medicine men daily entertain a curious throng. The visiting artist can be taken as part of the show. To keep the curious at bay, I hire a sharp-tongued guide, rise early, and work during school hours. But school finished early the day I made this drawing, and I was swiftly engulfed by children who cut me off from sight of my material. I ended up like the Pied Piper, followed by the curious children as I walked around the other entertainments to complete the drawing. Completed in three long hours with Faber Markettes, a 6B sketching pencil, Japanese and sable brushes, Pelikan Fount India ink, and Grumbacher watercolor. Courtesy, Weekend Telegraph, London.*

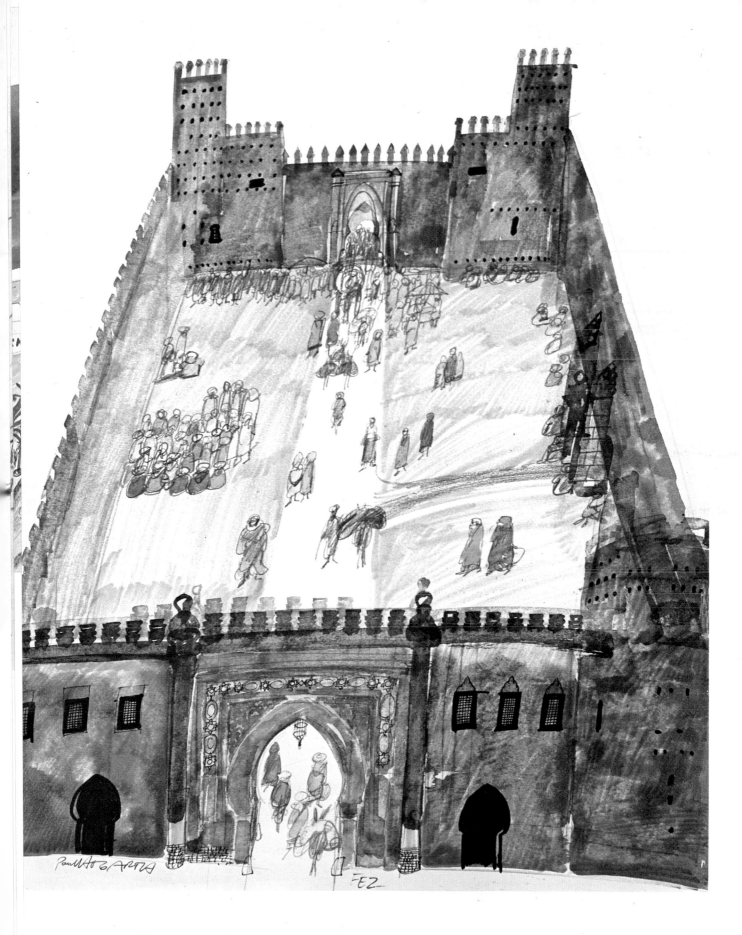

FEZ

Paul HOGARTH

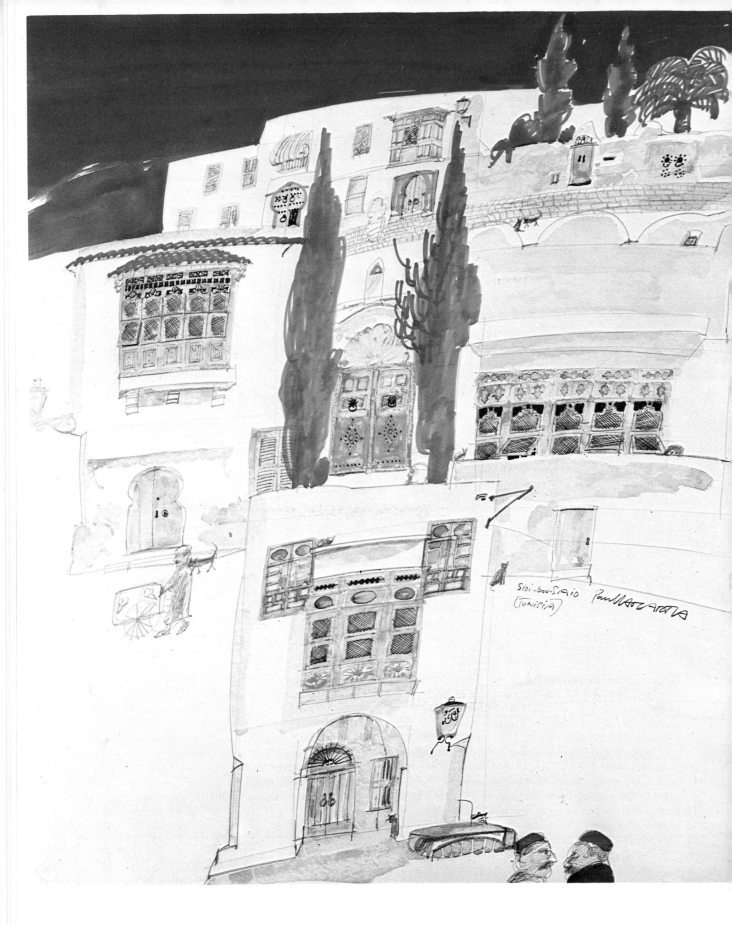

Sidi-bou-Said Paul HOGARTH
(Tunisia)

Sidi-bou-Said, Tunisia, 1966. *(left) Perched on Cape Carthage, above the dark blue Mediterranean, is luxuriantly colorful Sidi-bou-Said—one of the most enchanting places I have ever visited. I was moved to paint with felt-tip color markers, using watercolor only for those shades and hues the markers could not give me. Drawn with Faber Markettes, augmented with Grumbacher watercolors, in a 20″ x 16″ sketchbook of Daler cartridge paper. Courtesy, Weekend Telegraph, London.*

Street Scene, Sidi-Kacem, Morocco,*(above)An echo of past French influence, coupled with the presence of the ubiquitous Beatles, prompted me to stop and make this drawing in Morocco. Drawn in a 10½″ x 14″ Planet sketchbook of cartridge paper, with Faber Markettes, a 6B Faber sketching pencil, and an Esterbrook fountain pen filled with Pelikan Fount India ink. Courtesy, Weekend Telegraph, London.*

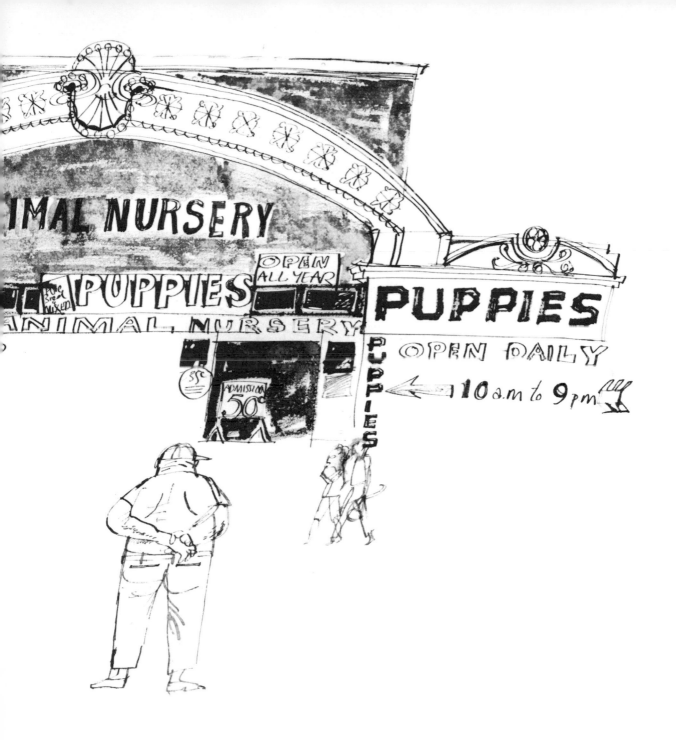

Animal Nursery, Coney Island, New York, 1963. *The precision of a line drawn with a quill or steel pen combines well with a line painted by a brush. I used a Spencerian steel school nib, a turkey quill, and a Japanese brush with Higgins India ink on Saunders paper. From Brendan Behan's New York, 1964. Courtesy, Hutchinson Publishing Group, London, and Bernard Geis Associates, New York.*

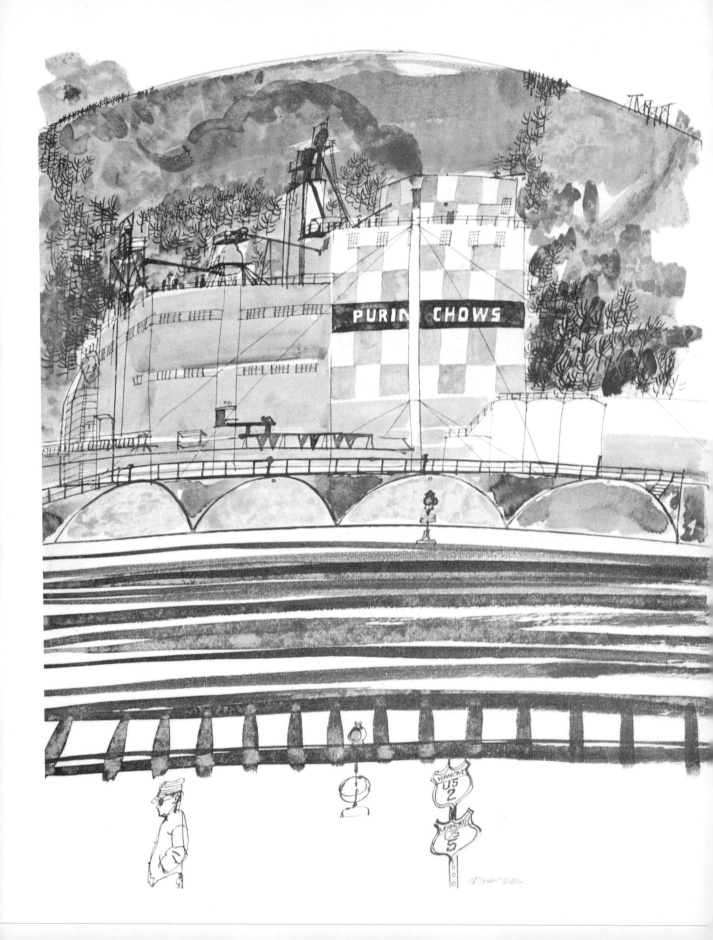

Paul Hogarth - Coal Barn, Montague (Vermont)

Purina Chows Plant. *(Left) In this drawing, I combined wiry pen lines (for the architecture and the pattern of the trees) with broad strokes of brush and ink wash, blotted in some places to create a more lively tone. Courtesy,* Fortune Magazine. *Copyright, December, 1963, Time, Inc.*

Coal Barn, Montague, Vermont, 1963. *(Above) Looking very much like a cow barn, this structure has silos for four different grades of coal. Drawn with a Japanese brush on Saunders paper in Higgins India ink. The railroad track was rendered with a Spencerian school nib. Courtesy,* Fortune Magazine. *Copyright, December, 1963, Time, Inc.*

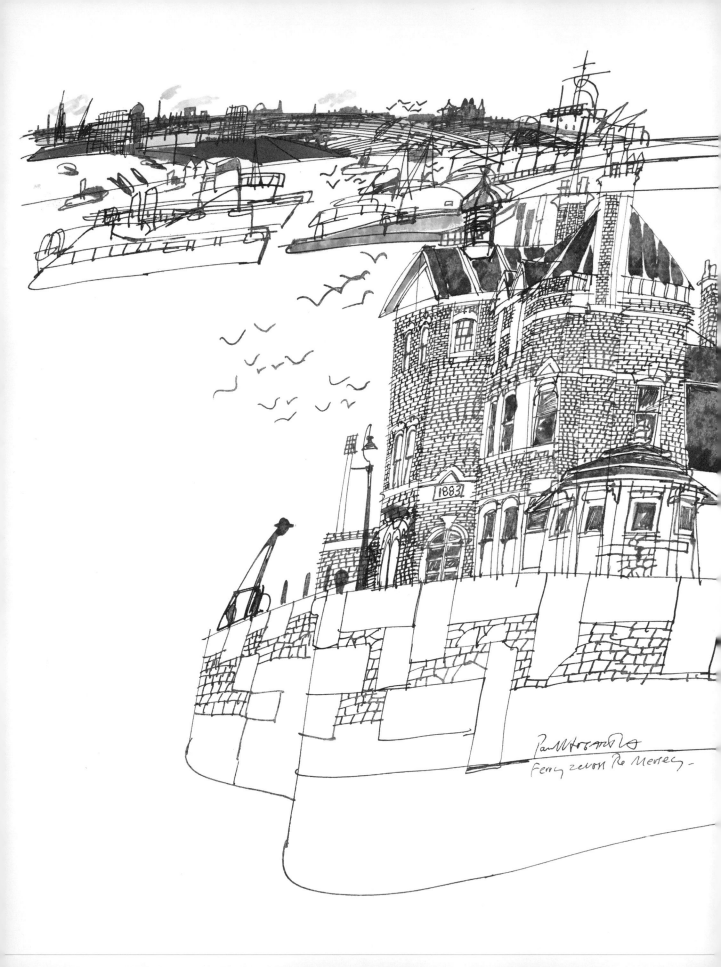

Ferry zeron Re Mersey -

8/Drawing for publication

So far, I have confined myself to talking about the techniques of drawing with various ink media. It seems logical to discuss ink media in relation to drawing for *publication* in printed media.

There is no doubt that ink is the most versatile medium available to the illustrator, whatever sphere of publishing you may be working in. Ink is applicable to *every* type of editorial and advertising art. Look at the illustrations in this chapter alone. These give you some idea of the wide range of techniques that can be obtained with a single medium — like a steel or bamboo pen, brush and wash, etc. — or mixed media like felt-tipped color markers combined with graphite. You will note that some of the more complicated drawings were reproduced just as effectively as the simple line drawings. Certain technical changes in printing have now made this possible.

Drawing for Letterpress

Hitherto, illustrations in ink media have been largely restricted to line drawings or wash drawings for reproduction by the line or halftone processes of *letterpress* — which means that drawings are printed from lines and dots that project from a copper or zinc plate, somewhat like the letters on an office rubber stamp. The limitations of these processes impose a certain discipline: artists are compelled to work in a certain way in order to avoid obvious pitfalls, if their work is to reproduce effectively.

To be reproduced by the line process, a drawing has to be sharp and contrasty, if not necessarily bold. It has to be made with *un*diluted ink on white paper or board.

A drawing for reproduction by halftone imposes even greater restrictions. Because the original is transformed into dots that project from a metal plate — the dots vary in density according to the quality of paper used for printing — much of the drawing's quality can easily be lost. Therefore, a drawing must have clearly defined tones, with any textural effects contrasted against a light background, or the texture will turn to mud.

Halftone is often used to reproduce editorial graphics, newspaper advertisements,

Ferry Across the Mersey, Liverpool, 1965. *Without any loss of quality, a fine flexible nib like the Gillot 303 or the Hunt 101 appears thicker on a very good cartridge paper. This phenomenon makes a 303 nib particularly suitable for city scenes with lots of Victorian brickwork. This drawing was made in Reeves India ink with touches of brushwork, in an 11" x 14" sketchbook of two-ply, medium surface Strathmore drawing paper.*

fashion drawings, story illustrations, and cartoons. For book illustration and pictorial journalism, halftone is usually less successful than line drawing.

These limitations do not always have any visible effect. Certain artists have developed a style which lends itself to reproduction and these men excel in creating lively and original illustrations unhampered by technical problems — for example, the work of Milton Glaser in the United States and Alan Aldridge in England. Nevertheless, the limitations of reproduction always have had an inhibiting effect on illustrators like myself, whose work is improvised, unpredictable, emotionally uncertain like painting, rather than planned and predictable like graphic design.

Drawing for Offset

Today, dramatic improvements in reproductive techniques have completely transformed drawing for publication. *Letterpress,* although still widely used, no longer possesses the influence it once had on magazine and book illustration. There are few drawn images that cannot be satisfactorily reproduced by the latest techniques of *offset,* and a free style of illustration — no holds barred — has emerged.

In modern offset printing, much finer screens — hardly visible to the eye — can be used, even for printing on cheap papers. *Offset* is perhaps the best process available for reproducing drawings in ink or pencil media in mass circulation magazines and books. The finest, most delicate, most personal drawings executed with subtle media like diluted or blotted ink will reproduce almost as they were drawn.

There is the same high degree of fidelity with *gravure* — less widely used than offset — but even greater depth of tone and richness of color.

In short, when you have an assignment to make drawings for publication, it is important ask *how* the drawings will be reproduced. Letterpress will impose tighter limitations on you than offset or gravure.

Making Your Own Color Separations

The methods of reproducing a drawing in two or more colors are basically the same as those already described for a black and white drawing. But there has to be a separate plate (called a block in Great Britain) for each color.

If a drawing or illustration is prepared by the artist on a single surface — that is, with all colors drawn on a single sheet of paper — the platemaker (or blockmaker) will use photographic means, requiring filters, to *separate* the various colors and

Book Jacket, 1965. *A great variety of tonal and textural effects is possible with nothing more than a steel pen, a brush, and a bottle of black India ink. This design was drawn on Hollingworth Kent Mill paper, in Higgins India ink, with Gillot 303 and 290 nibs, plus a Winsor & Newton No. 6 sable watercolor brush. The second color was drawn with the same brush in lamp black on a Kodatrace overlay, and then blotted. Originally reproduced by letterpress. Courtesy, Doubleday and Company, New York.*

The Origins of Scientific Economics

WILLIAM LETWIN

make a plate for each. This is common practice for large illustrations in full color, reproduced in advertising or in magazines with large budgets. For smaller illustrations of a modern character — children's books, covers of paperbacks, etc. — it saves a limited budget and it is often more interesting to make your own separations.

Each color should be drawn on a separate sheet of acetate or transparent vinyl which will enable you to see what is going on without a light box or tracing table. I usually make a start on these after I obtain editorial approval of same size color roughs. First I draw a pair of sight marks (or register marks) in the form of a cross (+) on each side of the rough drawing, 2″ to 3″ from the edges of the drawing. I then place my first sheet of acetate or vinyl on the rough and separate the black or "key" drawing, tracing freely from the rough and developing the idea further. This can be done with lamp black or with India ink conditioned by a few drops of anti-crawling fluid, since plain India ink does not take to shiny surfaces; you can also buy frosted acetate, which does take plain India ink. The remaining colors — drawn on a separate sheet of acetate, laid over the rough, for each color — can then be executed in any order you wish. It is best to use black to represent each color on its separate sheet of acetate.

This is not as mechanical a procedure as it may sound. I find that I am still discovering better ways of making a texture or a more interesting shape in my separations, right up to the time I should be mailing my finished art to the client.

Corrections and Alterations

If any part of your original drawing is to be altered or corrected, take care that the result is as invisible as you can make it.

For minor alterations or corrections, a good process white or photographic white — *not* the Chinese white used by watercolorists — should be used. This is the only white that appears really *white* to the cameras of the platemakers.

If you value your work after it is published and hope to preserve it for sale or future publication, Pelikan Graphic White or Luma Designers White are recommended. Unlike standard makes of process white, these will not yellow in time.

If paper patches are used for larger alterations, they should be made of thin matching paper, or their edges will throw unwanted shadows. These may actually appear as dark lines when reproduced. This can sometimes be avoided by filling up the crack with white paint.

Book Jacket, 1962. *Drawn in Winsor & Newton India ink with Gillot 290 and 303 nibs on Hollingworth Kent Mill paper, with patches of Zipatone. Originally reproduced by letterpress. Courtesy, Penguin Books, England.*

USE YOUR RUSSIAN

A BBC PUBLICATION TWO SHILLINGS AND SIXPENCE

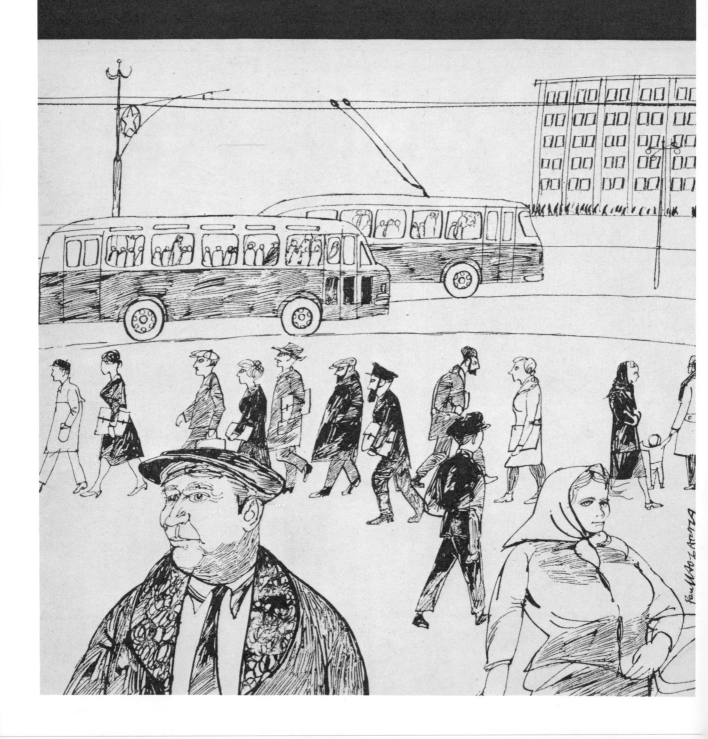

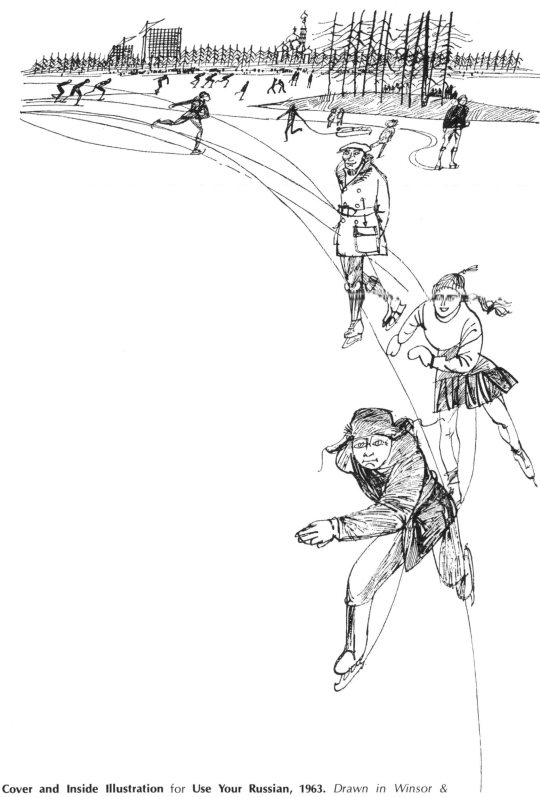

Cover and Inside Illustration for **Use Your Russian, 1963.** *Drawn in Winsor & Newton India ink with a reed (bamboo) pen on Hollingworth Kent Mill paper. Originally reproduced by letterpress. Courtesy, British Broadcasting Corporation.*

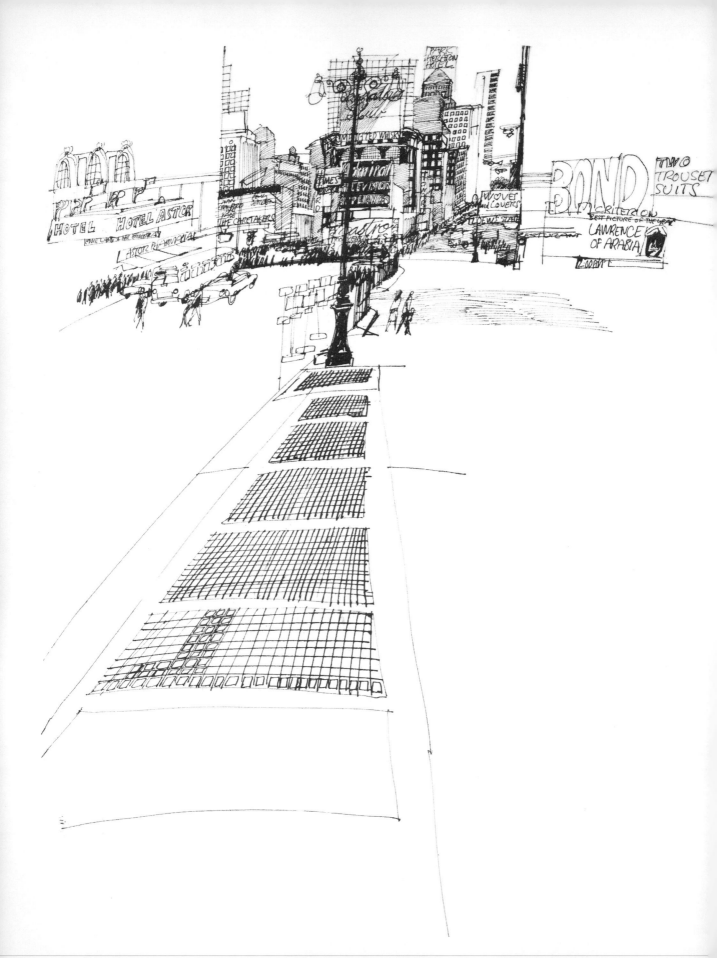

Drawing for Jacket of **Brendan Behan's New York, 1964.** *(Left) Hutchinson's art director, Hugh Williams, asked for a cover drawing that would catch some typical aspect of this great city. Since this drawing would appear with type, I left out superfluous details and reduced the scene to the essentials — a scissor-like composition which would easily relate to a typographical arrangement. Drawn in Higgins India ink on Saunders paper, with a Gillot 303 nib. Originally reproduced by offset lithography. Courtesy, Hutchinson Publishing Group, London, and Bernard Geis Associates, New York.*

Book Jacket of **Brendan Behan's New York, 1963.** *(Above) The drawing as it finally appeared. Courtesy, Hutchinson Publishing Group, London, and Bernard Geis Associates, New York.*

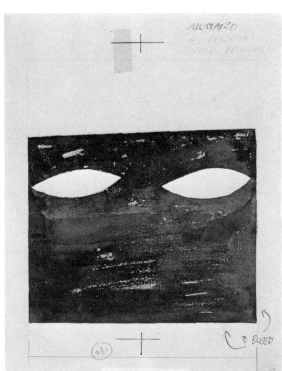

Original separations *drawn on tracing paper for book jacket on facing page.*

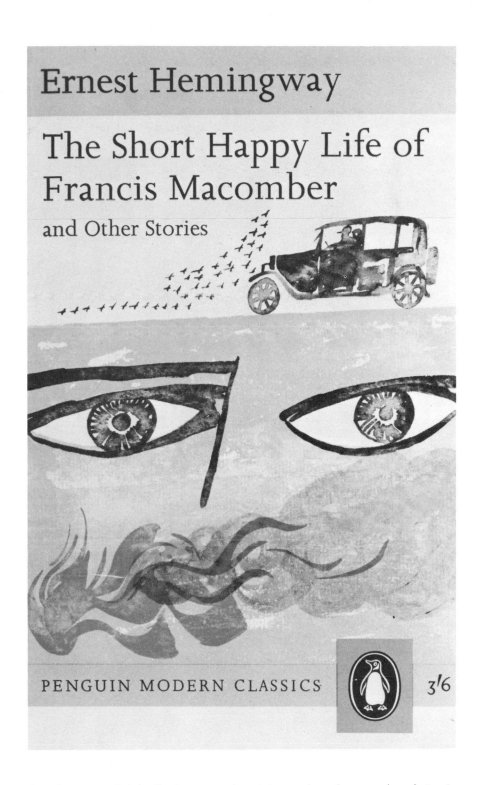

Book Jacket, 1963. *Originally drawn one fourth larger than the reproduced size in India ink brush line and blotted washes. A tracing paper of good quality was used for both the key drawing (black) and the orange separation. Strathmore script paper was used for the mustard separation. Originally reproduced by letterpress in black, orange, and mustard. Courtesy, Penguin Books, England.*

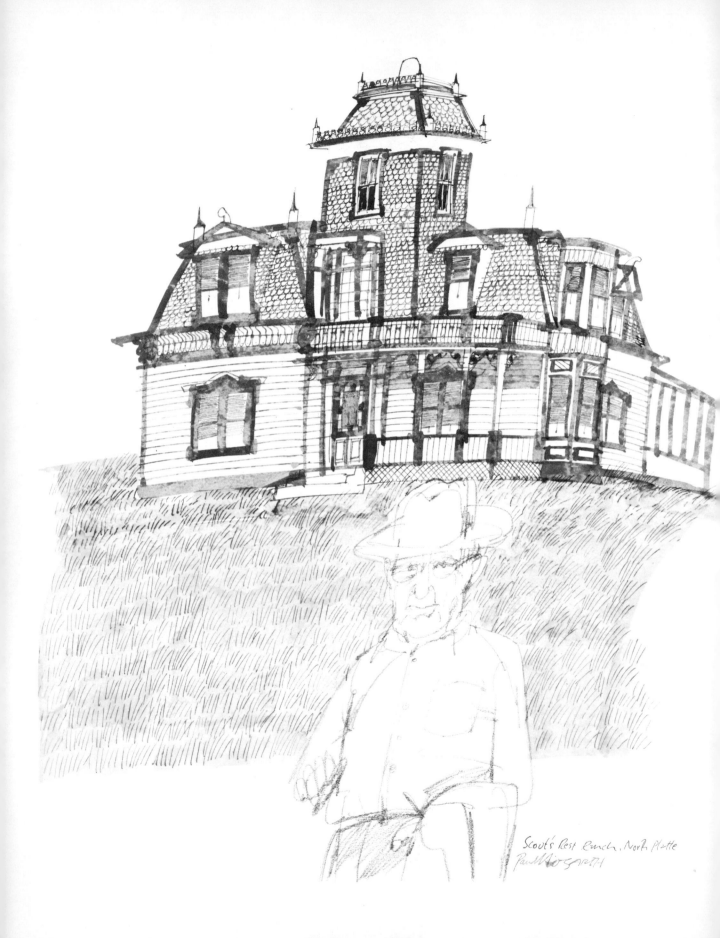

Scout's Rest Ranch, North Platte
Paul Hogarth

9/Drawing people

I draw people in a much more stylized manner with the medium of ink than I do with pencil. I find that ink allows me to place them in settings or situations where texture and color can be more boldly exploited. Ink also allows greater precision, so I can work on a small scale on location. For example, I can conveniently use small sketchbooks which are ideal for working in an inconspicuous manner in public places.

Sketching on a Small Scale

I worked a great deal in sketchbooks while travelling about Russia in the spring of 1967. These drawings were usually made at the theater, in a restaurant, or in a vast department store. Such places are impossible or embarrassing to work in on a larger scale because an artist makes himself such a prominent target for public interest.

I usually began one of these Russian drawings after I had looked around for ten minutes or so, during which time I would think of a pictorial idea which lent itself to a closer, more intimate approach than I would usually make. One such drawing was done in the Leningrad Maly Theater, after I had been struck by the fact that in the Soviet Union the magic never-never-land of Strauss's music evoked an even stronger response than elsewhere.

This spectacle of mass enchantment had to be confined to the single page of a 7″ x 5″ sketchbook placed on my lap. I had, therefore, to *select* a limited number of actors for my small drama, which I did by assembling my own audience from those theater-goers whose facial expressions revealed their emotions most visibly.

Using Figures in Larger Drawings

In larger drawings, figures usually play a slightly less dominant role than in smaller ones. Nevertheless, figures are vital because they introduce the sometimes necessary element of tension. Moving in or around the center or the foreground of a landscape or a cityscape, figures can add a note of mystery, excitement, and humor which often lifts a drawing out of the doldrums and gives it vitality.

Scout's Rest, North Platte, Nebraska, 1965. *In this, his favorite ranch, Buffalo Bill Cody entertained everyone from royalty to cowboys. Japanese brush drawing in diluted washes of Higgins India ink and a 6B Venus graphite pencil. Drawn in an 11″ x 14″ sketchbook of two-ply, medium surface Strathmore Alexis drawing paper. Courtesy, the Strathmore Paper Company, West Springfield, Massachusetts.*

Incidental or not, figures should be carefully observed, as well as carefully realized in character. This means embarking on a sustained program of observing and drawing people wherever and whenever they can be found. I know this will immediately raise feelings of uncertainty in the minds of those who are very easily put off by the unwelcome interest of passers-by. But you are timid only if you feel you cannot impress others with a skillful display. Skill in drawing, like skill in dancing or swimming, has to be built up gradually. I soon discovered that as my own drawing ability increased, so did my confidence to work on location.

Getting Used to Drawing People

Before you attempt to brave such possible outside interest, get thoroughly used to drawing people. Start by simply observing them unnoticed. For example, study people through a window. The Victorian English draughtsman Charles Keene used to do this continually; he then found he could see even more by using a large mirror fixed at an angle. In this way, unobserved, he could watch the colorful changing life of the London Strand, which he chronicled for the journal *Punch*.

Importance of Life Drawing Study

I found it easier to work from a model before I ventured to work on location. Life study is basic to understanding the human figure. Unfortunately, most life drawing classes are conducted in such a tedious manner that it is hardly surprising that many students find them unbearable places to learn anything about drawing. Life drawing is probably the most neglected area of art training. It suffers from either an over-academic or a placidly diffident approach, in which the student is encouraged to render the figure as if it were a lifeless plaster cast, instead of a living, breathing organism.

Yet the whole subject of life drawing really springs to *life* when a few simple aids are employed, such as drawing from *moving* figures or from models with masks. The moving model builds up speed of observation; masks reduce the recognition of an all too familiar art school model, heighten the feeling of the bizarre, and encourage *interpretation,* rather than an overly literal representation.

Studying Past and Contemporary Masters

Drawings of figures may derive their inspiration from life, but they draw their power from art. Close study of figure drawings by past and contemporary artists will help you develop a personal preference in matters of taste and style. Observe how other artists have tackled subjects similar to your own. Try to blend into your own technique the admirable qualities you observe in their work. My own short and unorthodox list would include the following artists whose vision of the figure is always refreshing and surprising: Francis Bacon, Jules Feiffer, George Grosz, Hokusai, Gustav Klimt, Toulouse-Lautrec, Jules Pascin, Saul Steinberg, Egon Schiele, and Miklos Vadasz.

Café Figaro, Greenwich Village, New York, 1965. *Drawn with an Esterbrook fountain pen filled with Pelikan Fount India ink, in an 11″ x 14″ sketchbook of two-ply, high surface Strathmore drawing paper. Courtesy, Strathmore Paper Company, West Springfield, Massachusetts.*

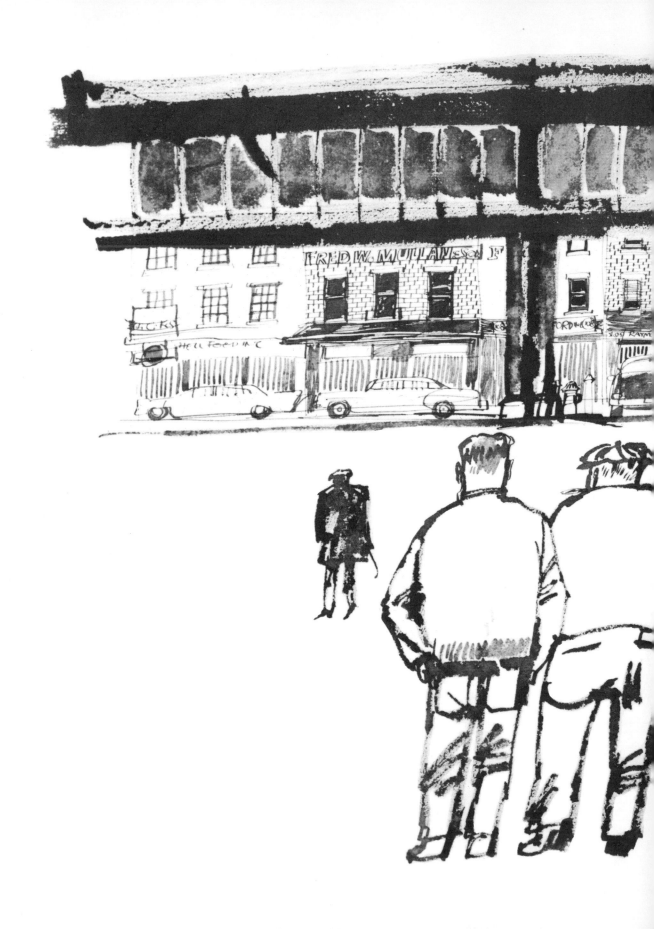

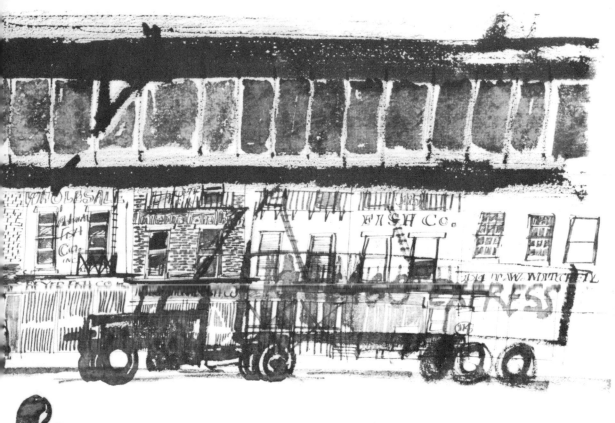

Fulton Street, Lower Manhattan, 1962. *I drew this scene with a fully charged Japanese brush, occasionally blotted, and then added figures and buildings with a Spencerian school nib. Drawn with Higgins India ink on white Saunders paper. From Brendan Behan's New York, 1964. Courtesy, Hutchinson Publishing Group, London, and Bernard Geis Associates, New York.*

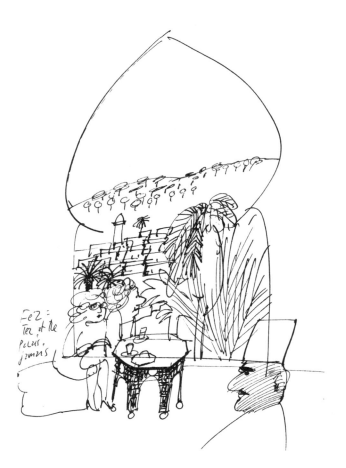

Fez =
Tea at the
Palais
Jamais

Two Sketchbook Studies, 1965. *These rapid studies were made respectively in Morocco and Tunisia with a Parker junior fountain pen filled with Pelikan Fount India ink. A 5″ x 7″ Planet sketchbook of cartridge paper was used. Courtesy, Weekend Telegraph, London.*

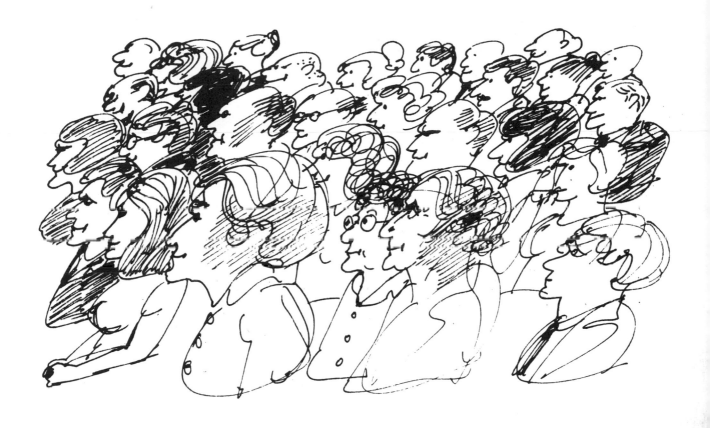

At the Maly Theatre, Leningrad, USSR, 1967. *This vignette of Russian life was drawn in the theatre itself, with a regular Esterbrook fountain pen, in a 5" x 7" English Planet sketchbook of smooth cartridge. From* A Russian Journey: Suzdal to Samarkand, *1968. Courtesy, Cassell and Company, London, and Hill and Wang, N. Y.*

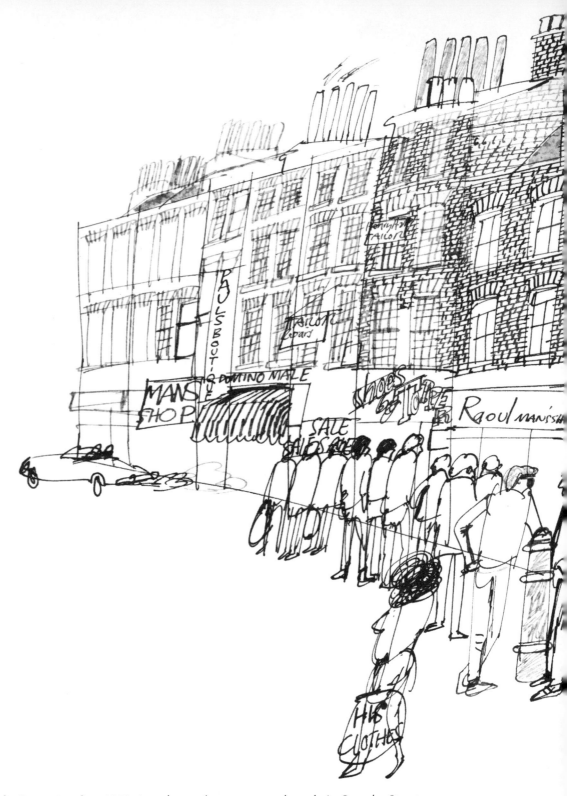

Carnaby Street, London, 1966. *A cockney who once owned a cafe in Carnaby Street reminisced as he watched me draw: "Full of pubs five years ago," he cried. "Nagh the kids are blueing it all on clobber." Saturday afternoon is clobber (clothes) time. Mods come in from all over London to buy the latest gear. Drawn with a Gillot 303 nib and a Japanese brush, using Pelikan Fount India ink on Strathmore script paper. From* London à la Mode, *1966. Courtesy, Studio Vista, London, and Hill and Wang, New York.*

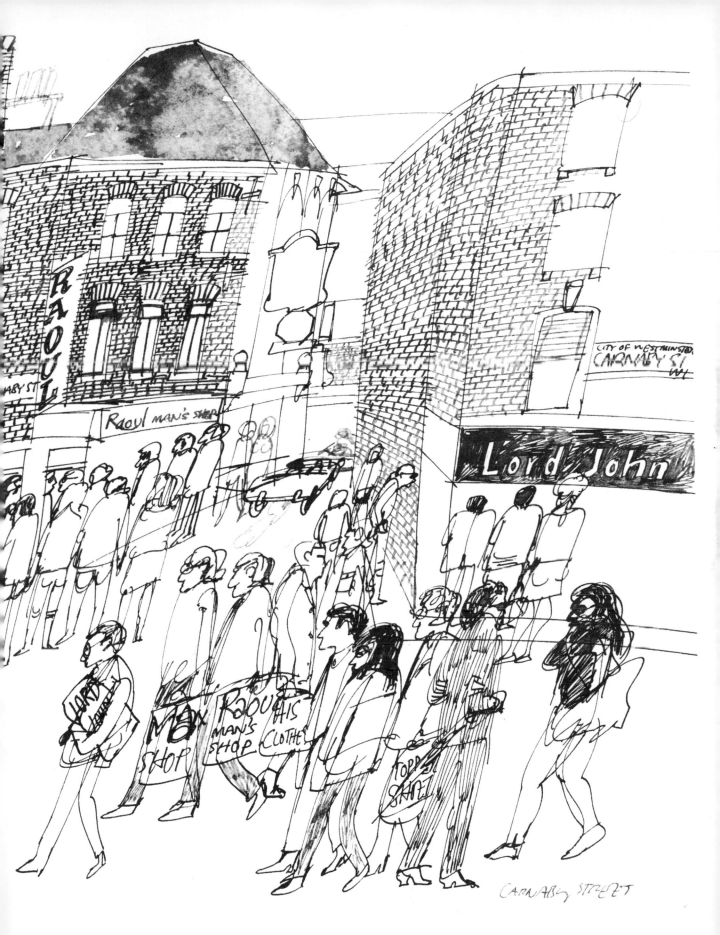

CARNABY STREET

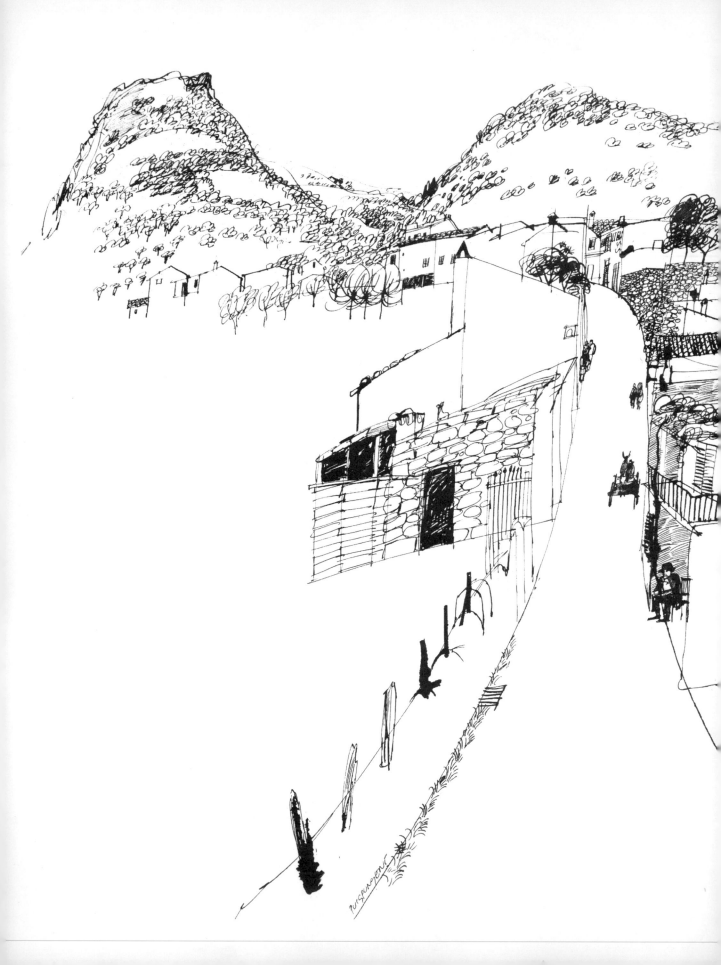

10/Landscape drawing

Drawing landscapes is a much more leisurely process of discovery than drawing people, and I go about it in a much more relaxed frame of mind. Although I find it stimulating to work on location because one is *living* as well as *working,* I do tire of the noise and tension of the city. So I welcome the times when I can slip away and make good my escape into the deeps of the countryside or to the remote seasore. On these occasions, I have the opportunity to reflect on the shapes and movements of natural forms, enabling me to face again the pressures of working in crowded city streets.

Visualizing the Subject

Having discovered the terrain that arouses my interest, my immediate problem is finding a way to visualize my personal reaction to it. This is not always as easy as it looks. Ideas for drawing a landscape come much more slowly than ideas for treating architectural or industrial subjects. Sitting down and taking in what is going on around me can be the best point of departure, often a more productive one than wandering about looking for the "best view."

I take notes of possibilities for juxtaposing elements that possess textural or dramatic qualities: a tree or mountain against a clear or clouded sky; crops or grass against stone; growth against decay; or life against death. I scribble a "must" or "very good" in my pocket notebook, and I record the best time of day to return and draw it if I cannot get it down at the time.

Selecting the Best Light

In the summer, the best times to draw a landscape are probably in the early morning (shortly after sunrise), late afternoon, or perhaps early evening. I always avoid the intense light of midday, which usually eliminates tone and color, as well as flattens

Puigpunyent, Majorca, 1963. *Closely observed detail is perhaps as vital to the slightest sketch as it is to the most complex illustration. In this sketch, I followed the line of the street and picked out a stone wall, a mule cart, a vine, and a seated figure to help convey the atmosphere of rural tranquility. I used an Esterbrook fountain pen filled with Pelikan Fount India ink, in a sketchbook of Daler cartridge paper. From Majorca Observed, 1965. Courtesy, Cassell and Company, London, and Doubleday and Company, New York.*

117

the forms of incidental details. Toward evening, as the sun sets and shadows slowly lengthen, a subject will be charged with a mood and atmosphere entirely absent during the day.

In the autumn, on the other hand, almost any time of day is good for drawing. The now diffused sunlight infuses the slowly dying vegetation with an intense and poignant aura which makes it the best season of all to draw landscape.

Drawing on Impulse

I often see a subject I feel compelled to draw immediately, without making notes. This is an old urge of mine, born from fear that I may never again see what I am looking at. This habit of drawing on impulse is so strong that I do not have the slightest hesitation in stopping whatever I may be doing and starting to sketch, even if it brings a certain amount of temporary discomfort.

In Morocco in the autumn of 1966, I remember driving at great speed from Marrakesh to Fez, desperately trying to make up for a whole precious day lost in waiting for a torrential rainstorm to subside. I had worked hard in Marrakesh and was relaxing during the long, fast drive on the straight and lonely highway. Then I entered the lunar wilderness of the purple hued Haouz Plain in the mountains of the Middle Atlas, wondering at the strange, fort-like farmsteads with their fences of brush. It was like waking from a deep sleep, but I had to stop. I had to make something out of this one! Although this capacity to recognize a subject immediately is very useful to acquire, I advise you never to *expect* to find a subject ready-made.

Improvising in Landscape Drawing

Generally, working creatively outdoors makes greater demands on the imagination than you might expect. This is particularly true of landscape drawing where, it would seem at first glance, the material is not quite so rich or concentrated as it is in the city. If less concentrated, landscape material is equally rich; but one needs a more resourceful attitude to recognize it.

Consequently, I improvise freely by regrouping scattered natural elements and man-made objects, organizing them in a single image whether they lay before, behind, or to both sides of where I am seated. I may also enlarge elements or objects to make them dominate their surroundings.

The relationship of the natural and the man-made can really make landscape drawing both lively and interesting. I usually look around with great care and note down objects that might be added to the stylized shape of a mountain, a rock strewn beach, or a sunburnt plain. I might note an unusual tree, an artesian well, an isolated house, a boat or net—any of which, if drawn in the right way, might immediately contribute to a more striking and dramatic image.

I am always careful to watch for examples of movement in a landscape. A flock of birds or goats, some passing or working figures, or even a moving machine can often add a needed element of tension to a tame or static composition.

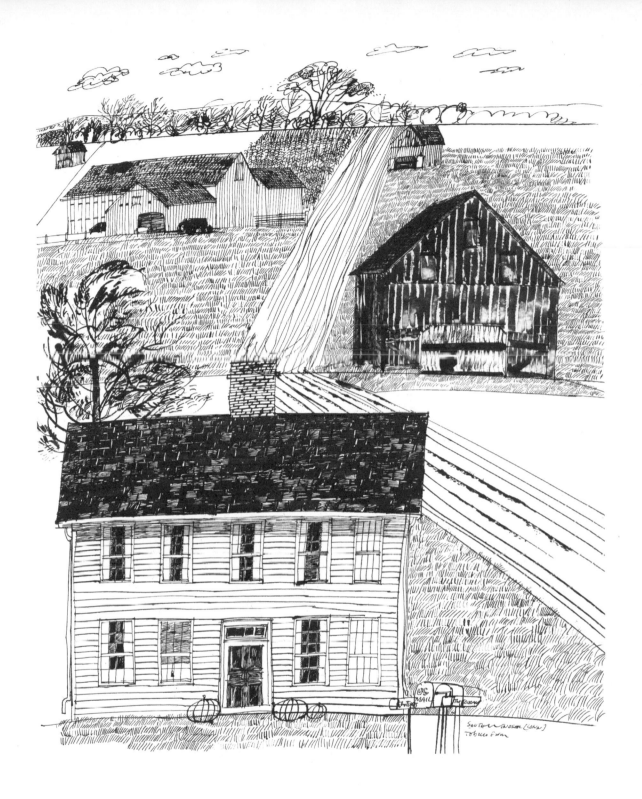

Fall Landscape, South Windsor, Connecticut, 1963. *This Connecticut tobacco farm was drawn on Saunders paper in Higgins India ink, with broad and fine nibs and a Japanese brush. House and foreground detail were rendered with a Spencerian school nib, the fields and distant farm buildings with a Gillot 303, and the black barn with a Japanese brush. Courtesy, Fortune Magazine. Copyright, December, 1963, Time, Inc. Collection, Mr. John Holder, Cambridge, England.*

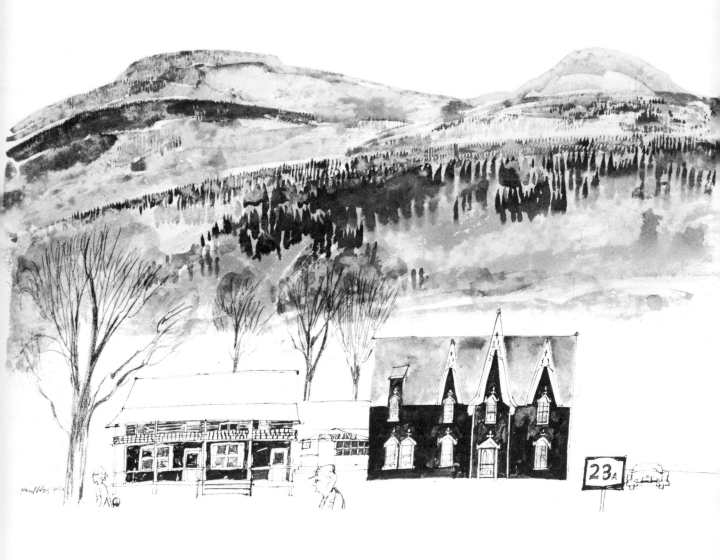

The Catskills at Palenville, New York, 1963. *(Above) This landscape was made with quite a mixture of media. The village store, highway sign, parked automobile, and passing figures were all drawn with a Gillot 303 nib and Higgins India ink. The sharply defined Victorian gothic house was drawn with a Gillot 290 nib and a Winsor & Newton No. 6 sable watercolor brush and textured blotter paper. The landscape itself was painted on Saunders paper in Pelikan watercolors, with a Japanese brush and Winsor & Newton No. 5 and No. 8 sable watercolor brushes. Trees in the foreground were rendered with a 6B Venus graphite sketching pencil.*

Regent's Canal, London, 1966. *(Right) "Watch out for the bridge, ladies and gentlemen. Little boys sometimes go the unmentionable!" warns the guide. The bridge in question was drawn with a fully charged Japanese brush, then swiftly blotted. The rest was done with a Gillot 303 nib and Pelikan Fount India ink on Strathmore script paper. From* London à la Mode, *1966. Courtesy, Studio Vista, London, and Hill and Wang, New York.*

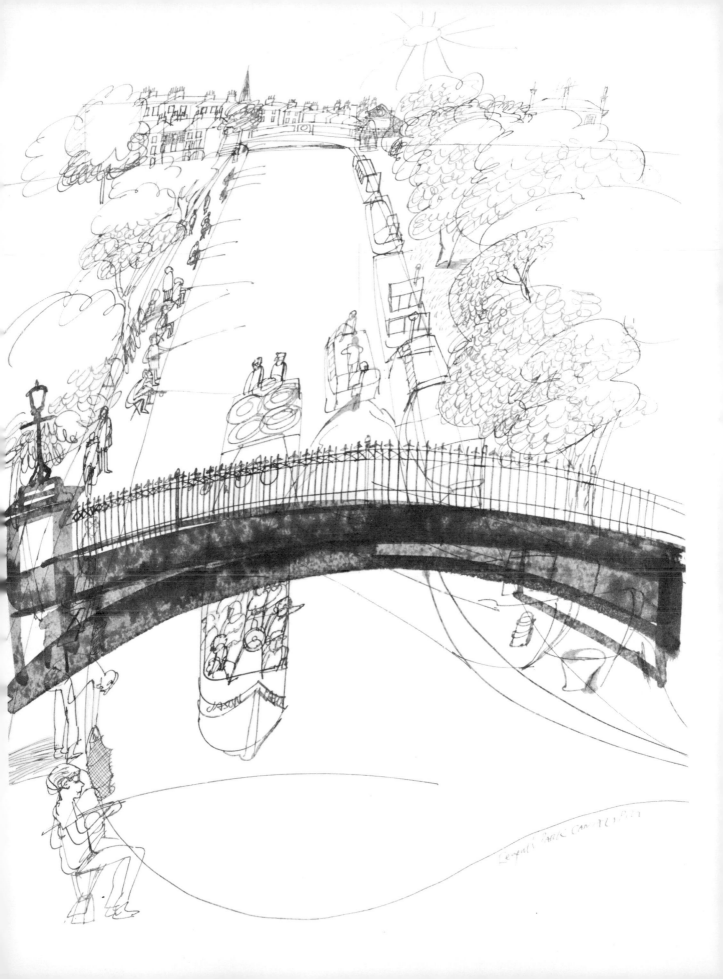

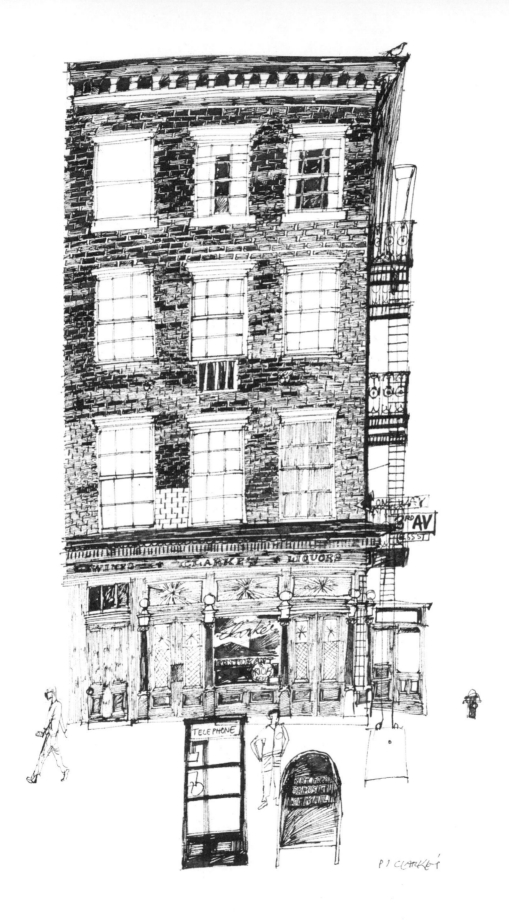

11/Drawing architecture

Perhaps drawing architecture *is* an acquired taste, but once you get hooked, it is not easy to stop! It is, I suppose, a way of expressing a personal reaction to history. Familiarity with the historical style and idiom of buildings is therefore a very necessary point of departure. I do not mean that a drawing of architecture should be the *literal* portrayal of historical edifices, but rather the lively interpretation of shapes molded by the ideas and purposes of their time—often seen against the life of the present.

Because I think of architecture in this way—and not as a dry exercise in perspective —size or complexity no longer worry me as they once used to. Without the slightest hesitation, I may flatten out a building in a spreading two dimensional type of composition which seeks to develop the subject as a *shape* to be filled with color, texture, and incidental detail.

Deciding What to Draw

Deciding what to draw is my first step. Here I may be guided by the different affinities I have toward the style of a period: the 1870s frame houses of upstate New York along the Hudson River; London movie-house Aztec of the 1930s; or Moscow apartment house *art nouveau* of the 1900s. I develop such preferences for style by seeing movies, by reading, or simply by drawing buildings of *all* periods before discovering one architectural style that compels me to make an entire series in whatever city or country I may find examples of them.

Whatever the period that interests you, practice seeking out such buildings and drawing them. This practice sharpens your sense of selection, particularly if you live in a city where one's sense of observation becomes blunted by familiarity with the *general* character of a district at the expense of its *particular* architectural elements.

P. J. Clarke's, Third Avenue, New York City, 1963. *In this famous old bar, worldly men discuss matters of moment in an atmosphere of mahogany, beer, and cigar smoke. But as much as I love its convivial interior, the varied texture of its exterior makes a crisper view of this prototype of Irish-American saloon architecture. Several nibs were used (mainly Gillot 404 and 303), plus my usual school nib, with touches of ink laid on with a No. 6 sable brush, then blotted. Higgins India ink on Saunders paper. From* Brendan Behan's New York, 1964. *Courtesy, Hutchinson Publishing Group, London, and Bernard Geis Associates, New York.*

Researching Your Subject

Reading about the social or historical background of architecture can provide the necessary impetus to enable you to go ahead and see the fabric of historical structure with a much deeper sense of excited commitment. If the period is entirely new to you, this research, of course, is particularly essential.

I started completely from scratch when I undertook a Time-Life assignment to recreate the life and architecture of Constantinople (the ancient capital of Byzantium, now the great Turkish metropolis of Istanbul). My enthusiasm to tackle a whole series of buildings was only acquired by the intensive research I embarked on after I had read the story script for which my drawings would be used. This study so effectively caught my imagination that when I actually began to work in Istanbul, I often sat before the remains of ancient buildings in a state of controlled excitement —so conscious was I of their historical past. Not only did my research provide the necessary energy to complete the series, but it also offered me all kinds of incidental ideas about how I could best carry out the drawings.

Deciding How to Draw Your Subject

Deciding how I will draw a building usually depends on how much time I have. But no matter how little this may be, I usually take a good look around a building so that I can actually *save* time by making a firm general decision about how I am going to draw it.

Because of the extra work involved in drawing architecture, I make sure to jot down my ideas in a small pocket notebook, even if I do not feel like making the finished drawing on that particular day. I work out various alternative compositions which place pivotal buildings against smaller, less important ones, or even within the context of a landscape. Sometimes I may even condense a large, elaborate building into a foreshortened vertical shape. I also look around for elaborate memorabilia, such as heavy Victorian lamp standards which can be placed against a facade or an area of color.

I may not always follow these notes of my initial reactions to interesting material, but this exploratory process does enable me to get the bit between my teeth by overcoming my uncertainty and hesitation about how I will actually make the drawing.

Deciding When to Draw Your Subject

Since buildings look very different in morning light than they do in afternoon or early evening light, I also note the hours they are at their best for my purpose. I have drawn ship-like *art nouveau* apartment complexes against a declining sun just because the silhouette effect enhanced their spooky quality. Victorian city halls and Renaissance palaces, on the other hand, are often best drawn in the light of early morning, which reveals the details of their massive, extravagant structures. Citadels and castles nearly always look their dramatic best toward sunset.

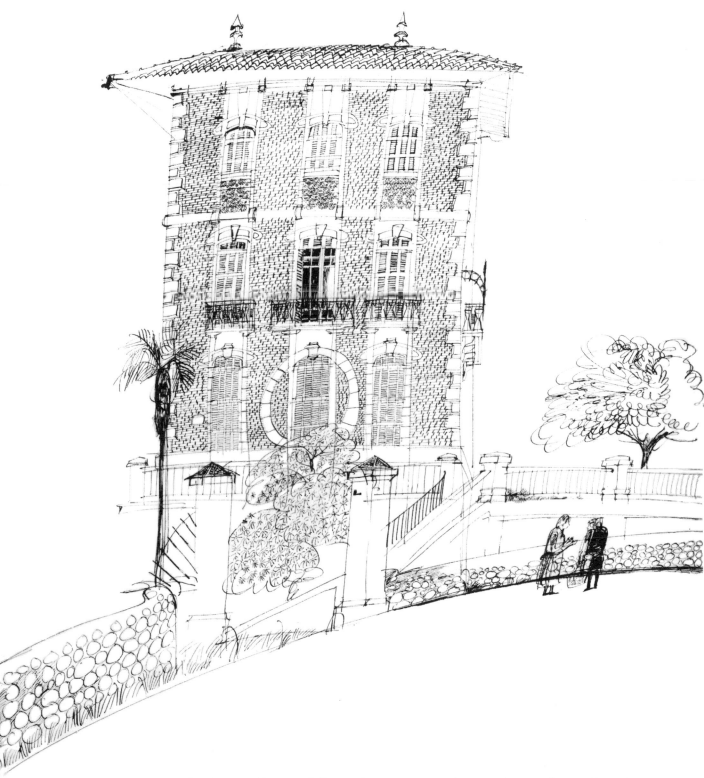

Art Nouveau House at Soller, Majorca, 1963. *For this superb example — well worth the three hours it took to draw — I used a Gillot 303 nib and Higgins manuscript ink on Saunders paper. From Majorca Observed, 1965. Courtesy, Cassell and Company, London, and Doubleday and Company, New York.*

As important a consideration as lighting is noting the best time to work. There is *nothing* as traumatic as finding yourself engulfed in a jostling, home-going multitude which brings the police in its wake to investigate the cause of the obstruction — you!

Time Limitations

Whether I make a straightforward or complicated drawing, in color or black-and-white, depends to some extent on how many drawings I can reasonably hope to make in the time I have. This is sometimes impossible to estimate, for one cannot always predict what might be discovered. In this respect, ink tends to be a more deceptive and unpredictable medium than pencil, particularly when one becomes involved with the vast textural possibilities of Victorian masonry — a time-consuming job.

An uncomplicated lineal technique, simply involving the use of a steel pen or brush, is the kind of drawing I am likely to make if I have only an hour or so, and have to make further drawings. If I have a greater amount of time, I make a more elaborate drawing, involving the use of color markers, watercolor, pens, and pencils. Such a drawing may take me two or three hours — or even the greater part of a day.

But, of course, you do not *have* to finish it all on location. In fact, it is often a good thing to complete a drawing in your room or studio. This enables you to have second — and, hopefully, better — thoughts about how to give a drawing its final shape.

Remedying a Lifeless Drawing

With architectural subjects, as with landscapes, one can sometimes produce an effective but lifeless interpretation. On these occasions, a little movement may help; it need not be human.

I remember feeling alternately satisfied yet dissatisfied with a large ink and watercolor drawing I had made of the luxuriantly decorative Tunisian village of Sidi-bou-Said. I felt the uneasiness of having missed something vital. Then I noticed cats moving in and out of the windows and doorways. So I drew them in and added a few more for good measure my drawing was completed.

Wooden Church, Suzdal, USSR, 1967. *One hundred and fifty miles east of Moscow, Suzdal, the old capital of Muscovy, offers visitors an immense variety of Slav architecture and imagery. I rapidly made this drawing with a pointed Japanese brush, using diluted and undiluted washes of Higgins Eternal Ink over pencil on Strathmore script paper. From* A Russian Journey: Suzdal to Samarkand, *1968. Courtesy, Cassell and Company, London, and Hill and Wang, New York.*

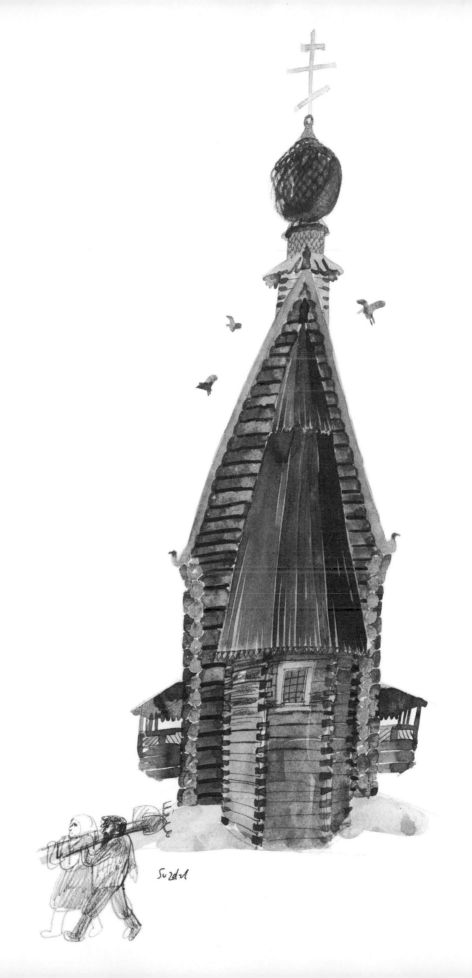

Suzdal

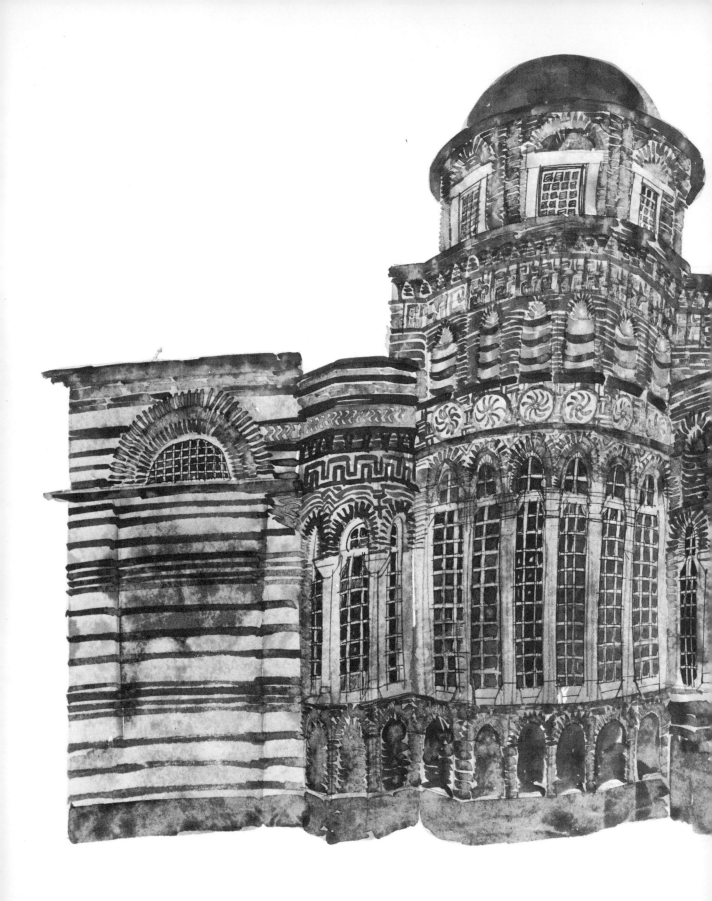

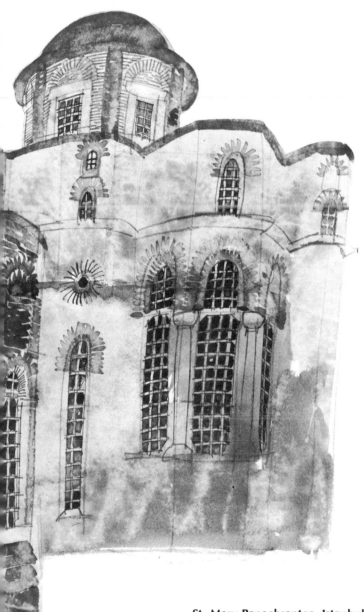

St. Mary Panachrantos, Istanbul, Turkey, 1966. *Byzantine architects lavished their skills on interior spaces and mosaics. The outside decorations were left to imaginative masons who spaced out stone with friezes and rosettes of brick in colored mortar. To convey all this, I first blocked out the shape of the church directly with a Japanese brush charged with washes of diluted Pelikan permanent black writing ink. I then painted decorative masonry with Winsor & Newton No. 4 and No. 6 sable brushes in undiluted Higgins India ink. A Gillot 303 nib was used to delineate the windows. Daler cartridge paper. From Byzantium, a volume in the Great Ages of Man series, Time-Life Books. Copyright, Time, Inc., 1966.*

Old Movie Theatre at Alcudia, Majorca, 1963. *(Above)* I took full advantage of the lineal qualities of ink to obtain this drawing of a tumbledown outdoor movie theatre. Drawn on Saunders paper with a Spencerian school nib, and augmented with washes of diluted Higgins India ink. From Majorca Observed, 1965. Courtesy, Cassell and Company, London, and Doubleday and Company, New York.

Street Scene, Staten Island, New York, 1963. *(Right)* This drawing was an exercise in nostalgia for American life of the 1900's. Houses of that time stop me dead in my tracks. I drew this Staten Island scene with a Spencerian school nib and a Japanese brush in Higgins India ink on Saunders paper. From Brendan Behan's New York, 1964. Courtesy, Hutchinson Publishing Group, London, and Bernard Geis Associates, New York.

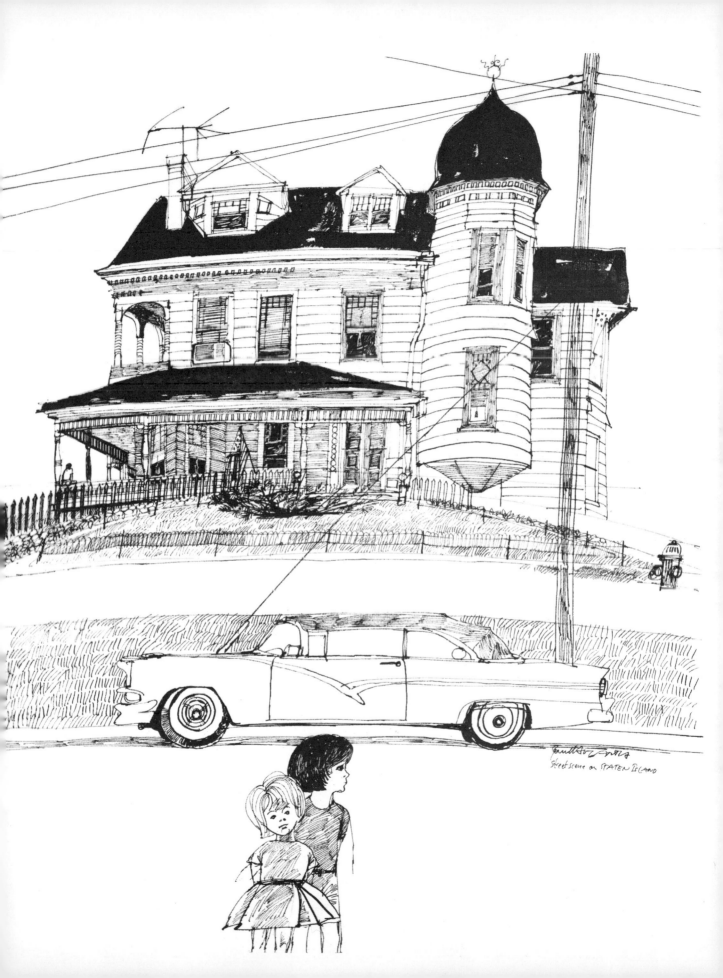

Street scene on STATEN ISLAND

HARTFORD = Dutch Point
extension to Highway 91 Interstate Highway
Paul Hogarth

12/Drawing the city

The city you were raised in or, better still, the city that has cast its spell on you through a movie, a book, or a personal description, can provide exciting drawing subjects. To live in such a city and absorb its moods and tensions is an incomparable experience, completely different from any other.

Choosing Your Materials

I draw city life with a high degree of emotional involvement and I gravitate toward the life that moves in and around places I loved as a boy: railroad stations, street markets, movie houses, junk shops, corner sweetshops, old cemeteries, and fun fairs were—and still are—an intimate part of my everyday world. I draw such places in every city I visit. Even today, I live in a district of Cambridge, England, which is full of slowly disappearing memorabilia.

Paradoxically, what enables me to recognize the esthetic interest of everyday material has been visiting strange and exotic cities: ancient cities like Peking, Istanbul, and Fez, where past still jostles with present; river capitals like London, Paris, and Leningrad, whose aura stirs my senses like old perfume; great commercial cities like Moscow, New York, and Johannesburg, full of the urgent tempo of modern life; industrial cities like Hartford, Pittsburgh, and St. Louis, whose esthetic qualities frequently escape the casual observer; and great seaports like Barcelona, Liverpool, and San Francisco, which the sea charges with magical vitality.

Old or new, capital or commercial, seaport or industrial, there is something worth discovering and drawing in every city.

Organizing Your Material: A System

Although drawing a city certainly makes different demands than drawing the countryside, people, or architecture, the basic problem remains essentially the same—the

Hartford, Connecticut, 1963. *The Hartford skyline is a curious mixture of past and present. Shiny glass office buildings and the unfinished extension to the Interstate Thruway make an effective backdrop for Samuel Colt's century-old firearms factory with the blue onion dome he received from a grateful Sultan of Turkey after fulfilling a rush order for five thousand revolvers. Drawn on Saunders paper in Higgins manuscript ink with a Japanese brush, a Gillot 303, and a Spencerian school nib. Courtesy, Fortune Magazine. Copyright, December, 1963, Time, Inc.*

problem of organizing your reaction to a subject into a pictorial idea, and believing in that visual idea sufficiently to follow it through to a complete drawing, whatever the circumstances.

Drawing is an expression of personality; but it is also a means by which to impose yourself on a strange or different environment. Give yourself a little time to achieve this. Even if you are used to travelling, even if you feel at home in the bustle and confusion of a big city, you may not be accustomed to drawing under such conditions. If this is the case, it is much wiser to draw villages or small towns until you can observe their life and buildings without feeling overwhelmed by noise or diverted by the attention of onlookers. It will enable you to adjust to working in a big city much more easily.

The main danger to your self-confidence is seeing too much! The immense variety of material often makes choice difficult and can reduce you to a state of utter helplessness. You must feel on top of experiences in order to observe them. It is very necessary, therefore, to have a system with which to digest the build-up of impressions. You can then conserve the emotional and physical energy to work.

Preliminary Research

My own system usually begins well in advance of any actual drawing. Before I even start out on a trip, I read novels and magazine articles, and I see movies. I collect all kinds of clippings and take them along in a folder to read or refer to while I am on the road. This helps me to dig a little deeper by bringing a great degree of imagination to my confrontation with the subject.

Touring the City

On arrival, however, I am briskly practical. I usually start by using whatever facilities will enable me to see as much as possible in the first few hours of the first day of my arrival. If my client has made the funds available, I hire a guide. If not, I join a conducted tour, or I work one out myself. At this stage, I try to avoid being left on my own. My aim is to get as complete a picture of the city as I can as soon as I can. I will have plenty of time to myself when I know where and what to draw.

If I do slip into a state of mental confusion, I stop working and relax for a day. If time does not permit such respite, I restrict my activities to a single neighborhood rather than continue to tour the big, outstanding places.

Taking Notes and Scheduling Time

During this reconnaissance, I make notes. These include a rough sketch of a possible composition, a description of the place where it is, and how to get there. The reconnaissance may take a day or a week, but after it is over, I look through my notes and make a selection of subjects.

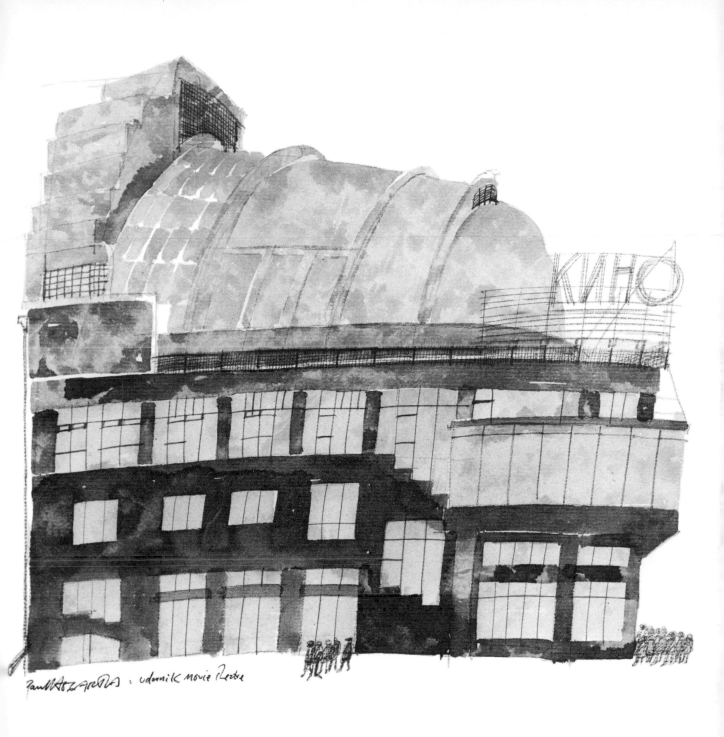

Udarnik Movie Theatre, Moscow, 1967. *Because I had very little time to spend on this drawing (which I nevertheless had to make for a number of reasons), I decided to use the simplest materials—brush and pencil. Drawn on Glastonbury antique paper, with a pointed Japanese brush in Higgins Eternal ink and a Faber 702 pencil. From A Russian Journey: Suzdal to Samarkand, 1968. Courtesy, Cassell and Company, London, and Hill and Wang, New York.*

First I eliminate any duplicate ideas, so that each remaining idea is unique. I then note the best time to draw each subject. I usually make a big drawing in the morning, reserving the afternoon for small or less complex material. I then work out a rough daily schedule covering the period of my stay. Only when this is done can I feel ready to go ahead and begin the actual drawing.

Of course, things may not work out quite as I plan, but making these preparations is nevertheless very important to my morale. It is an activity which enables me to move from one stage to another in an organized way, from taking notes to attempting a really creative interpretation.

In a single week, a typical schedule is likely to include the following: at least two large size composite drawings in color, done with mixed media (these are usually drawn in the central sections of a city); three or four medium size, black-and-white pen or brush drawings of single buildings or streets with people; and five or six smaller pen or quill sketchbook drawings of such typical imagery as a billboard sign, a street lamp, or the interior of an amusement arcade.

Working from Photographs

Many artists prefer to work from their own or from someone else's photographs. And, of course, there is certainly no reason why they should not. It is a question, merely, of what an artist personally needs as a point of departure. An artist like Gustave Doré would take one look at his subject, make the hastiest, scribbled sketch, and then return to his studio to create a large, elaborate drawing complete in every detail — so great was his capacity for total recall.

Unless I am involved in problems of literary or historical illustrations, I personally find photographs an unsatisfactory source of material. They simply do not move me, and I find the temptation to copy or be influenced by such photographs too great. On the other hand, the feeling of participation which I experience when I draw city life on location, or when I work from sketches drawn on location, stimulates my imagination and enables me to work in a much more spontaneous and improvised manner.

The student artist should consider an additional point. No matter how you may work later on, your immediate concern is to develop a personal drawing style. Such a style is more likely to develop from continuous location work than from relying on photographs. Only when an artist has acquired a distinct personal style can he work intelligently and imaginatively from photographs.

How to Cope with Spectators

The difficulty of working on location is, of course, that people will watch you. Keeping your cool while you work, therefore, is most important. I am referring to the uninvited audience who tend to regard artists as free street entertainment. A few hints on how to deal with this situation are vital, for acquiring the ability to cope with spectators can often mean completing or not completing a drawing.

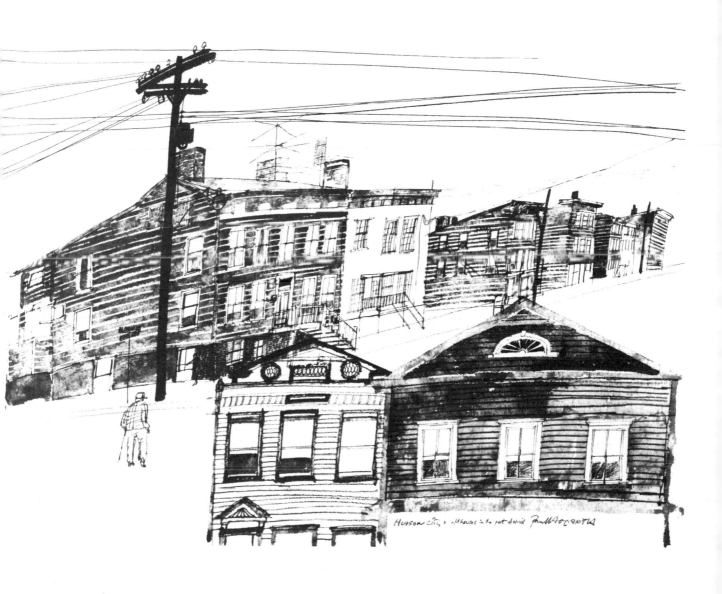

Hudson City, New York, 1963. *Founded late in the eighteenth century by the whalers of Nantucket and New Bedford, Hudson still looks like a whaling port, with its cluster of old wooden houses on the waterfront. Drawn on white Saunders paper in Higgins India ink and Pelikan watercolors, with a Japanese brush. Augmented with a 6B Venus graphite pencil and a Spencerian school nib.*

Your own attitude toward observers is really determined by your attitude toward people in general. If you do not like observers — no matter what their size or shape — you will certainly find working more difficult than you would if you are more easy-going. Like most artists, I find that I like people more if they seem to like what I do! Regardless of whether you are gregarious or anti-social, you can get used to working on location if you observe a few simple rules.

Some Basic Rules

Rule number one is to avoid wearing clothes that will make you the center of attention. This rule is particularly essential if you are a female. Next, always work from concealed or partially concealed positions. If you work with your back to a wall, you cannot be observed from behind. Few people are so bold as to approach you from the front. Street scenes can also be drawn from a parked automobile. It may be impractical to do so, however, in congested streets of America and Great Britain where parking restrictions may limit your time. Also, work on weekends whenever possible if you are drawing subjects located in the center of a city. The crowds are thinner on Saturdays (except in the shopping districts) and Sundays. Finally, avoid hordes of curious children by working during the hours when they are in school.

Spectators: Their Positive Value

Audiences are often a source of irritation, but they can be a source of confidence, too. When I first began to work on location, self-consciousness often prevented me from continuing if I was being observed. But the more progress I made, the less self-conscious I became. Like an actor, I now derive a precarious strength from my communication with the discriminating appraisal of an audience. I particularly appreciate the comments of spectators, if I feel blue or homesick, for this encouragement enables me to continue.

Manipulating Spectators

Sometimes an audience can get in your hair to such a degree that it is impossible to continue. But at other times, you may be able to manipulate an orginally disturbing audience to work for you! This has happened to me.

On one occasion in 1962, I was drawing a strip of Jewish and Puerto Rican stores on the Lower East Side of New York City. First one, then two members of a gang of teenagers stopped to watch me. I was given a run-down on everything and everybody that passed by. They asked me why I was an artist and wanted to know how much money I made. At first they irritated me. Then I realized that I would have behaved exactly the same way when I was a boy. Their questions simply expressed interest in what I was doing. In their own restless search for the meaning, they had stumbled on someone who apparently knew what to do with his life, and was working because he wanted to, not because he was told to.

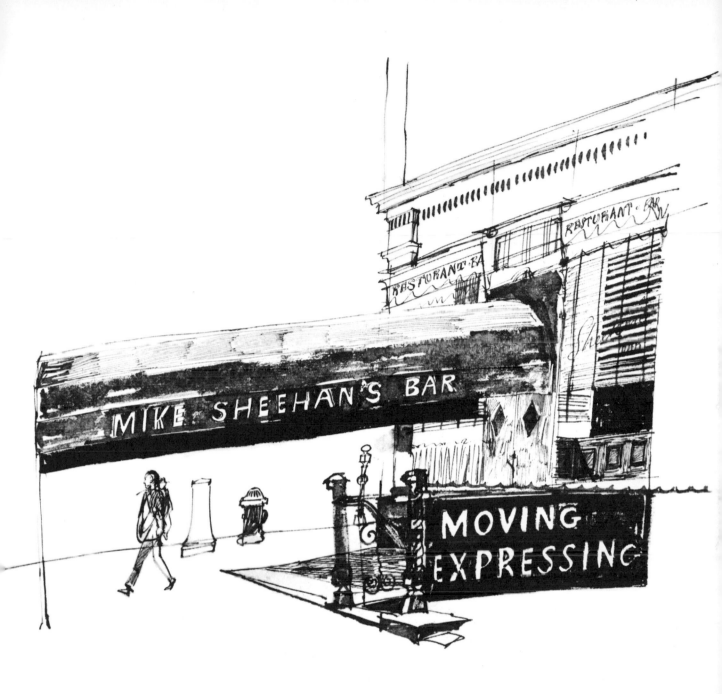

Sheehan's Bar, Third Avenue, New York City, 1962. *Drawn on white Saunders paper with a Japanese brush and a Spencerian school nib in Higgins manuscript ink. From Brendan Behan's New York, 1964. Courtesy, Hutchinson Publishing Group, London, and Bernard Geis Associates, New York.*

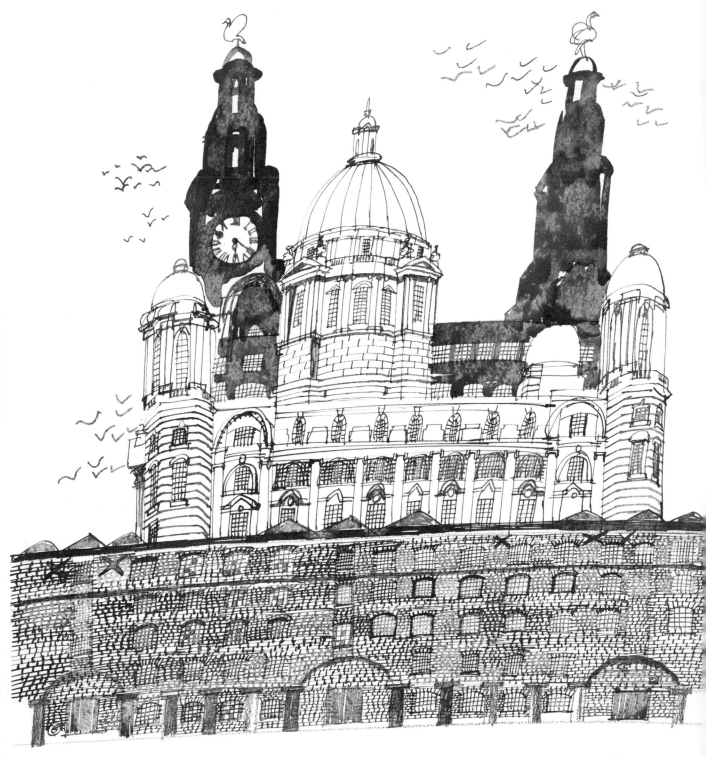

Liverpool
Paul Hogarth

Since it was not possible to continue drawing the street, I decided to draw the boys themselves. I set them against a background of a barbershop, and ended up with a conversation piece of the entire gang (*The Assassins*), plus one or two individual portraits. The boys departed in a good mood, and I had caught a very real element of city life in my street scene.

Handling the Baiter

Another difficult situation to handle is the appearance of a hostile joker, who openly baits you in spite of an interested audience. This person is usually a belligerent drunk or simply someone who has an urge to break things up. I usually ignore such a character and wait for some member of the audience — who is anxious to have me complete a drawing — to rise to the occasion and deal with the common enemy himself! I advise you not to get involved in such a dispute yourself, as you run the risk — if you do not speak the language — of lining up everyone against you when you play the role of the outraged foreigner.

Drawing a city, in short, is more than just looking around and getting a thrill from working imaginatively from reality. It also involves acquiring the patience and tact to understand and handle people whose only contact with art is *you*.

Royal Liver Building with Victorian Warehouses, Liverpool, 1965. *A simply composed drawing involving the use of blotted brushwork, open pen line, and a dense blotted pen line. Drawn with a Gillot 303 nib and Japanese brush on a graphite pencil outline, in an 11″ x 14″ sketchbook of two-ply, medium surface Strathmore drawing paper.*

The Riviera Bar, Seventh Avenue, New York City, 1963. *Named, no doubt, with the more carefree memories of the French Riviera in mind, this well known Greenwich Village haunt, flanked by the old Paperbook Gallery, made a good shape to draw. I used an Esterbrook fountain pen filled with Pelikan Fount India ink, and worked on a 14" x 17" Strathmore Alexis layout pad. From Brendan Behan's New York, 1964. Courtesy, Hutchinson Publishing Group, London, and Bernard Geis Associates, New York.*

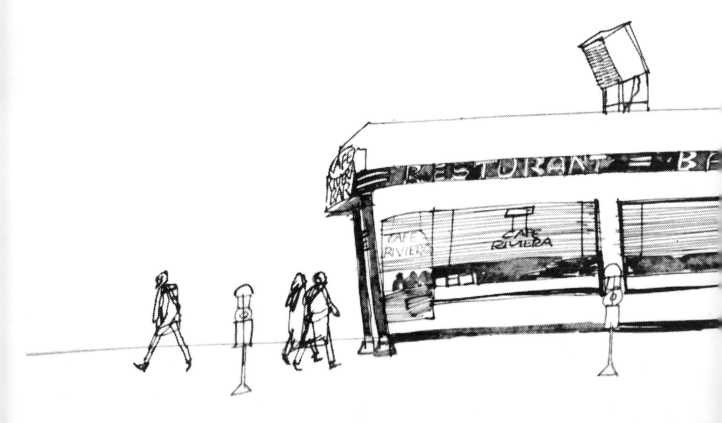

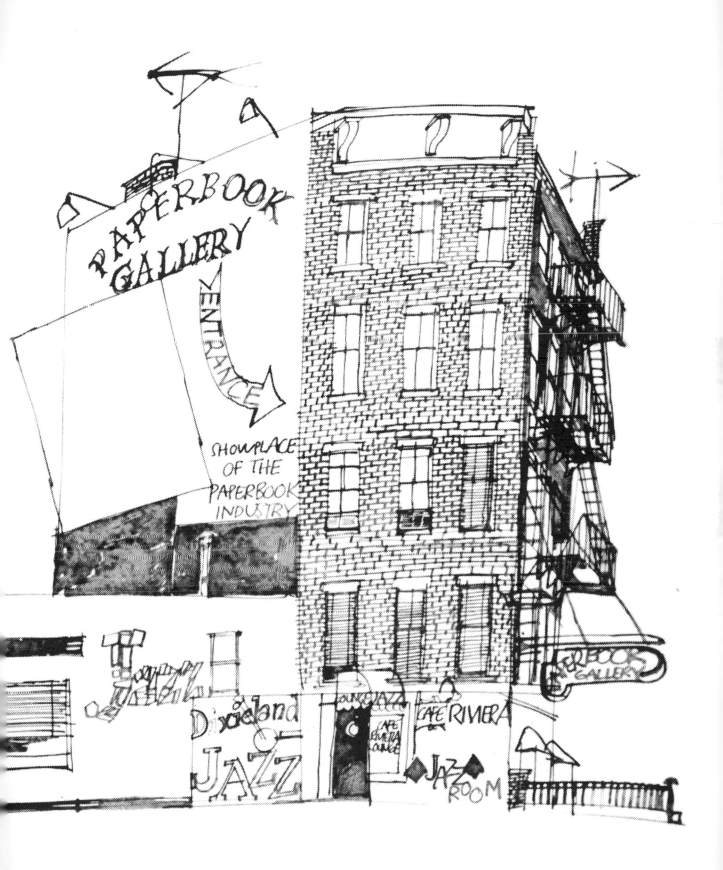

143

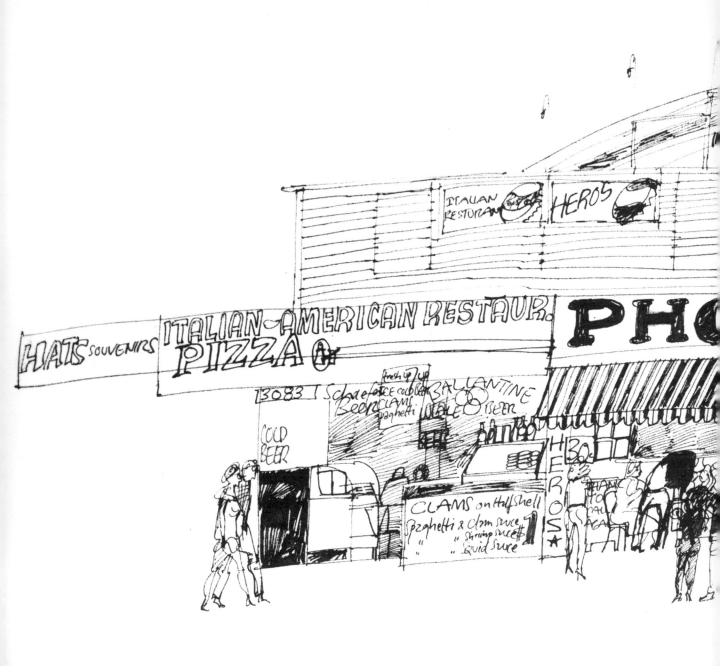

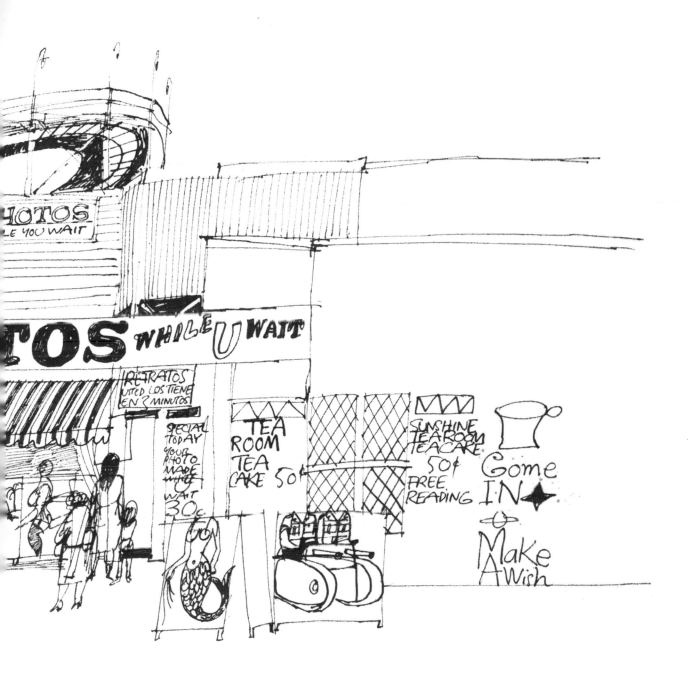

Coney Island Scene, New York, 1963. *Because of the amount of lettered detail, I used a Gillot 303 nib and Higgins Eternal ink to make this drawing on Saunders paper. From Brendan Behan's New York, 1964. Courtesy, Hutchinson Publishing Group, London, and Bernard Geis Associates, New York.*

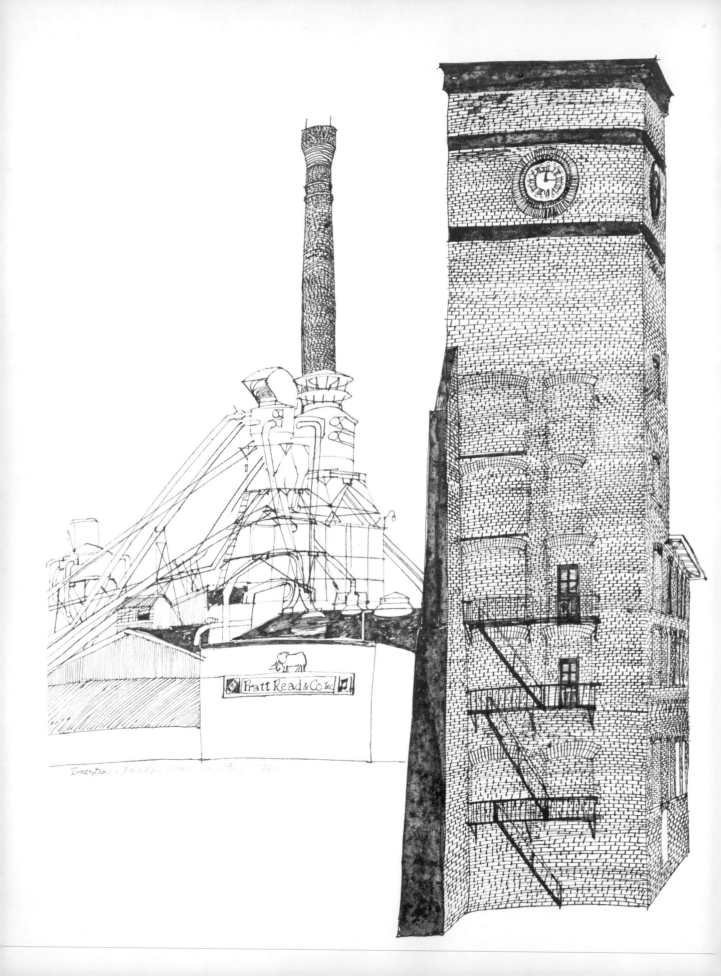

Ivoryton + Deep River, Connecticut, August '76

13/Drawing industry

Today's surge of construction and industrialization reflects the greatest and most ambitious technology ever devised by man. The stylized shapes of the new industrial plants and installations, with their science fiction interiors, compel a grudging admiration. Once more, the artist is encouraged to step outside his studio and come to grips with the physical results of man's constructive genius.

At one time, great industrial regions could be counted on the fingers of both hands. Today, however, industry is widely dispersed throughout the world. From the jungles of Africa to the rice paddies of Asia, men now assemble the means to produce the goods which, they hope, will eliminate poverty and hunger.

Revealing itself in such dramatic terms, this new world of industry also recalls industry's past with startling poignancy. In older industrial regions like the Connecticut River Valley, an occasional confrontation with the somber beauty of a Victorian cotton mill is no less breathtaking than the sight of a vast, modern power project in a hidden mountain valley. Old or new, industry offers the artist-illustrator a unique and adventurous sphere of activity.

Gaining Access to Plants

You may soon discover that it is not as convenient to draw industry as it is to draw a landscape or a cityscape. Although old mills and factories are often located in small towns, big modern plants are much less accessible. Moreover, for security and safety reasons, they are frequently off-limits to the unlicensed observer.

Generally, an artist will have no difficulty being admitted to a wide range of industrial plants — providing he is engaged in an educational project or an actual assignment. Medium size firms and giant corporations are conscious enough of their public image to have the necessary facilities to accommodate a visiting artist or group of students. Such visits can usually be arranged through the public relations office of the firm. Advance notice is essential; parties are usually limited to ten; and indi-

Old Pratt Read Plant, Ivoryton, Connecticut, 1963. *Pratt Read and Company started making ivory combs in 1798, then later switched its production to piano keyboards. Elephant tusks from Zanzibar used to be brought up the river. Today, the keys are made of plastic. Drawn with a Gillot 303 nib and a Spencerian school nib. The solid areas were filled in with a Japanese brush, then blotted. Higgins India ink on Saunders paper. Courtesy,* Fortune Magazine. *Copyright, December, 1963, Time, Inc.*

vidual artists, if engaged in an educational project or sent on an assignment, are admitted without difficulty.

The Artist: A Source of Publicity

The executives of industrial firms are interested in having artists and writers publicize the activities of their corporations. The number of magazines and newspapers published by many firms offer many opportunities for creative contributions which pass unnoticed or unknown by the majority of artists and students.

A perfect example of this kind of interest occurred in 1965, during the course of my tutorial work at the Royal College of Art in London. After a winter of intensive life drawing, my students felt they would like to tackle a project that would enable them to apply everything they had learned in class.

During that year I had drawn several portraits of industrialists for the magazine *Fortune*. One of the men who sat for me was Frits Phillips, the president of the giant international corporation, Phillips Gloeilampfrabrieken. The sitting had gone well, and I had been bold enough to ask Mr. Phillips if he would allow my students to draw in his factories. He not only gave his permission, but also supplied free air transportation! Several weeks later ten students and I were drawing glass blowing and TV assembly procedures at the vast Phillips complex at Eindhoven!

Not every student reacted creatively to the exacting demands of the project, but four who did contributed fresh, original views of the factory. Phillips liked the experiment as much as the students. A selection of the best drawings was published — and duly paid for — in the Phillips monthly picture magazine.

Most of my own drawings of such factories or industrial developments in various parts of the world have been made on assignment. I could not have visited them otherwise. Unless the boss happens to be your father, remember that industrial drawing is the one field where your activities will have to be sponsored.

How to Draw Industrial Plants

Many of the problems I discussed in regard to drawing architecture and cities can also be applied to drawing industrial subjects. How I decide to draw a factory again depends both on the time I have available and on the visual interest the shape or structure possesses. Moreover, a factory, like other subjects, looks very different at various times of the day. The drama of an old steel mill, for example, might better be emphasized by drawing it at night rather than during the day. On the other hand, daylight might be more appropriate to study an oil refinery or chemical plant whose formal intricacies require revealing lighting conditions.

Drawing the interior of a factory involves you in the same bustle and confusion as you find on a city street or in a neighborhood which contains a factory. It is therefore advisable to use similar approaches and procedures to systematically build up your impressions. Such a systematic approach will ward off confusion and help you

hold fast to your original purpose. My notebook habit is a particularly helpful aid in this area.

Many factories — even industrial installations — suggest an architectural approach. Whether or not I think of them in architectural terms depends a great deal on my personal reaction to such structures, and on whether the buildings themselves relate to human activity. Some may resemble immense machines that seem too powerful to be connected with mere man. For me, what really makes drawing industrial subjects different from drawing architecture or cityscapes is the convulsive atmosphere of energy that seems to permeate any industrial structure. In effect, I try to convey the feeling of a building in motion.

Today dams, highways, pipelines, and bridges are found in the most improbable settings. Power systems straddle remote mountain valleys; highways cut through forests and plains; underground pipelines run the length and breadth of continents; and bridges soar above rivers like giant spiders. But as various as these subjects may seem, they all overlap with landscape drawing and present similar problems requiring similar approaches and solutions. I advise you to try and see industrial installations as individual shapes which may be more effectively rendered by contrasting or relating them to their natural surroundings.

Drawing People at Work

Unexpectedly encountering men or women whose faces are stamped with the reality of handling complicated machines is a moving experience. Such an encounter can also mean embarrassment or shyness for an artist because our vocation is an exceptional one. I am tempted to advise you not to draw workers in factories until you have had plenty of practice elsewhere.

But after all, what *is* working on location? Drawing people at work is, in fact, the best school in which to master the exigencies of working on any location. This kind of drawing is a problem, however, only when you wish to emphasize someone's face or figure. I have found that the best way to break the inevitable tension of silence is to express your natural curiosity in what the person is doing. Once the ice is broken your work will go much more easily. Subject apart, confronting workers' inevitable reactions — humorous or otherwise — to seeing an artist in a factory has helped me develop a capacity to draw anywhere.

Using a Guide

If the public relations department of a firm offers you a guide, so much the better. The guide may not help you make a good drawing, but his presence certainly will inspire your confidence, for you know his assistance is available at any moment. I find the assistance of a guide vital to whatever kind of drawing I intend to make. I wlecome someone who — because he is affiliated with the organization — can justify my presence, explain my general intentions, and thereby introduce me on a professional basis.

Inside a plant, everyone is involved in complex processes of production which may not allow them to stop or be diverted for a single instant. Most factory work, however, is based on assembly-line production procedures. The movements of workers engaged in such activities repeat themselves over and over. I observe the routine and then draw as much of the movement as I can. When the movement has ceased, I complete the drawing from memory. The results of working in this way are much livelier than if a guide were to request a worker to suspend his activity and stand motionless until I "got it right."

I avoid perspective unless it can be used to advantage, and rely instead on creating a flat composition which permits me to develop the inherent shape of a machine, and then exploit any fantasy its form may suggest. Such an image, integrated with a figure or group of figures moving around or against a machine, makes a far more dynamic image than one which relies exclusively on perspective.

Ink Media and Industrial Subjects

You may find that ink media are not suitable to drawing every type of subject. For example, I find that I cannot draw satisfactory portraits with any kind of ink medium, and rely on the more tentative pencil media to undertake the kind of probing that portraits require. On the other hand, I feel that decorative elements can be rendered more successfully with felt and fiber-tip markers or steel and quill pens than with pencil media. Therefore, I use markers and pens to draw people working at machines.

When I am making large scale industrial drawings and am working against time, I particularly appreciate ink media. Using color markers in conjunction with blotted ink washes, and adding details with a fountain pen, I can make large, elaborate drawings in a relatively short period of time. The same effects would take me hours to create with any other kind of medium.

Everything I have learned—and still learn—from the relatively relaxed activities of drawing people, landscapes, cityscapes, and architecture is quickly poured into any industrial assignment I undertake. When the travelling is over and the drawings are done, I am left exhausted but exhilarated. In spite of this expense of energy, I find that drawing industry and the people who work in it presents the biggest challenge to my resources, initiative, and technical skill.

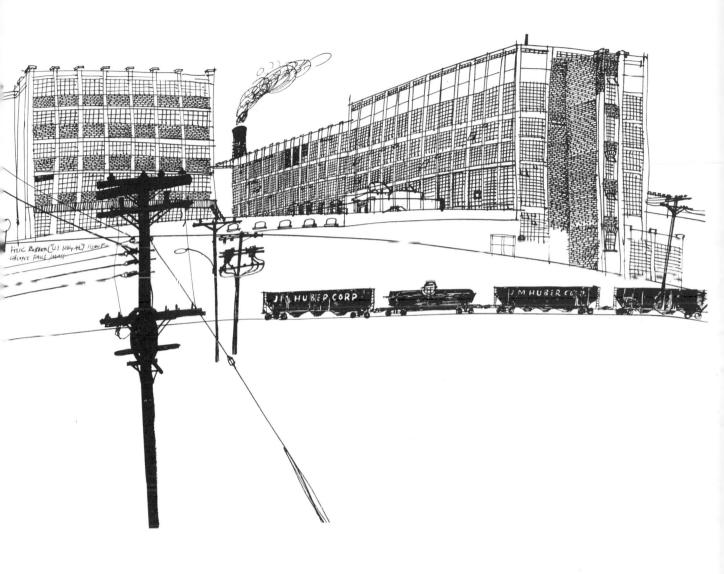

Fisk Rubber Plant, Chicopee Falls, Massachusetts, 1963. *Just what to leave out and what to emphasize is important in all drawing. It is especially vital in ink drawing. In this sketch, little else was needed to convey the character of the scene than emphasizing or contrasting the power cables and railroad freight cars against the open brickwork of the factory. Drawn with Gillot 303 and Spencerian school nibs, and a Japanese brush, in Higgins India ink on Saunders paper. Courtesy, Fortune Magazine. Copyright, December, 1963, Time, Inc.*

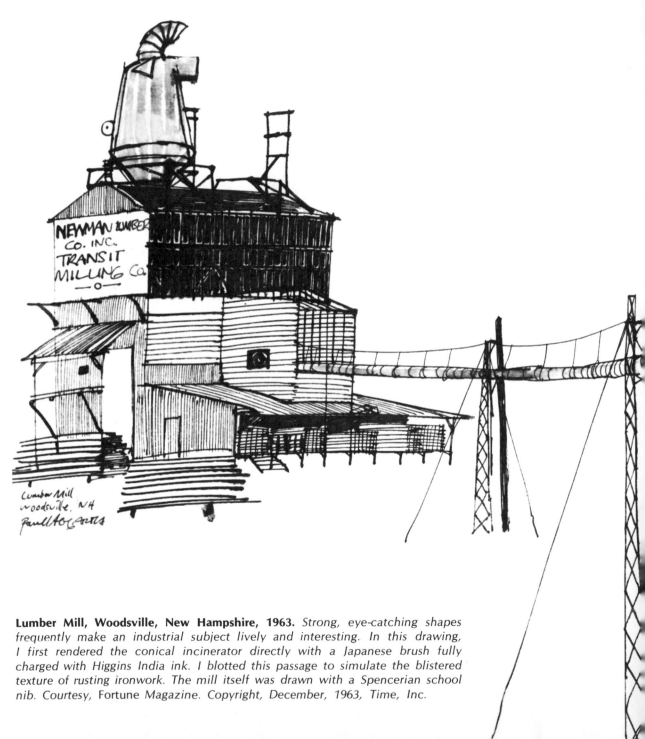

Lumber Mill, Woodsville, New Hampshire, 1963. *Strong, eye-catching shapes frequently make an industrial subject lively and interesting. In this drawing, I first rendered the conical incinerator directly with a Japanese brush fully charged with Higgins India ink. I blotted this passage to simulate the blistered texture of rusting ironwork. The mill itself was drawn with a Spencerian school nib. Courtesy, Fortune Magazine. Copyright, December, 1963, Time, Inc.*

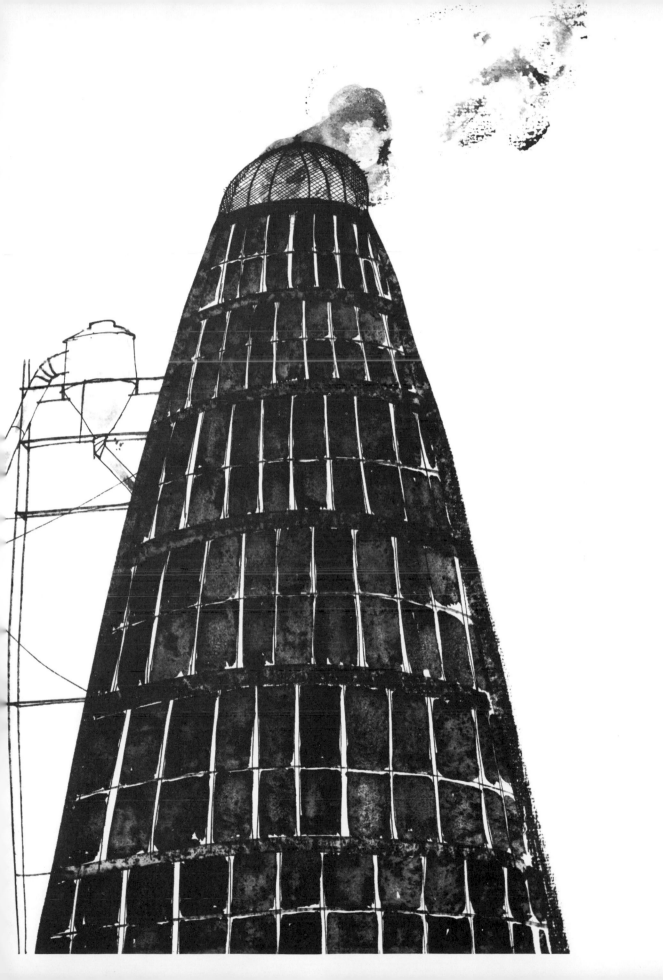

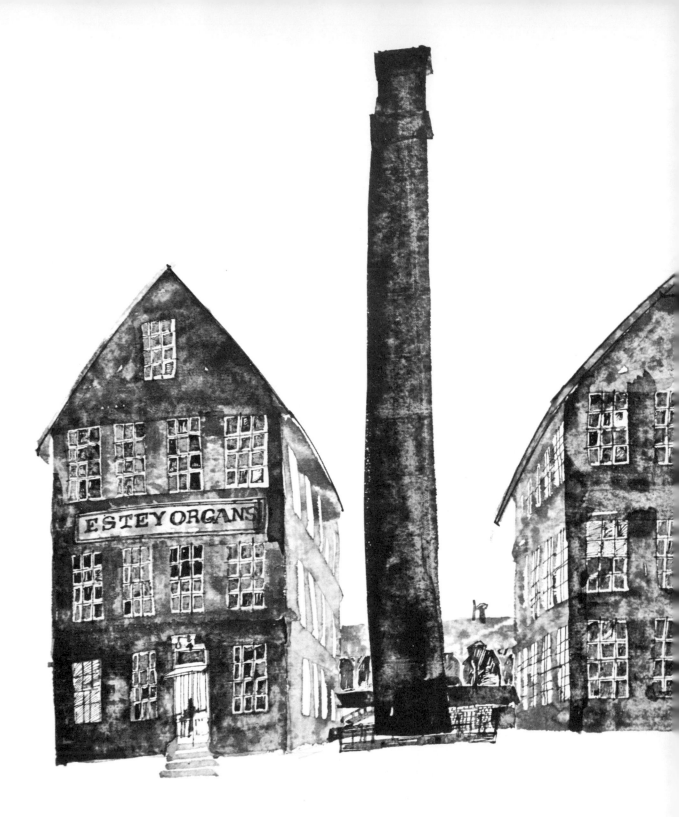

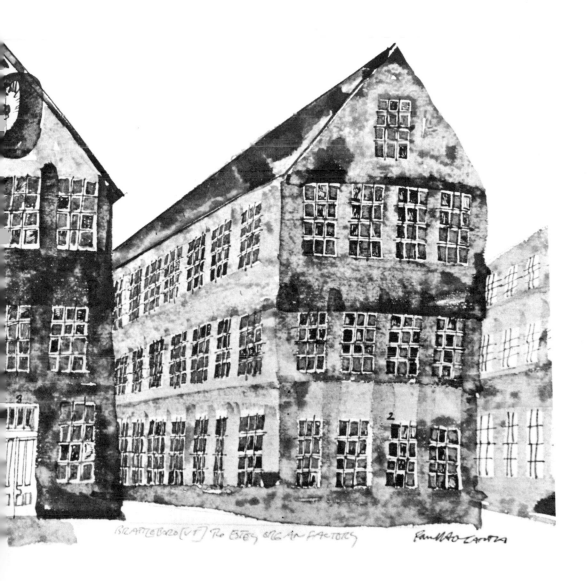

Estey Organ Works. Brattleboro, Vermont, 1963. *Perched on a terrace above the town, the old slate-sided works is now partly abandoned — although organs are still repaired there. Drawn on Saunders paper in Higgins India ink, with a Japanese brush and a Spencerian school nib. Courtesy, Fortune Magazine. Copyright, December, 1963, Time, Inc.*

Old Underwood Plant, Hartford, Connecticut, 1963. *Standing grimly just a few blocks away from the ornately glistening state capitol building, this Victorian typewriter factory typifies massive industrial architecture built along the Connecticut River in the latter decades of the nineteenth century. I worked directly with a Japanese brush to convey the drama of the plant's stark, monumental character. I blotted the ink strokes here and there, leaving areas where I could use a steel pen to fill in the pitted textures of brick, ironwork, and window. Drawn on Saunders paper with a Japanese brush and a Gillot 303, in Higgins India ink. Courtesy, Fortune Magazine. Copyright, December, 1963, Time, Inc.*

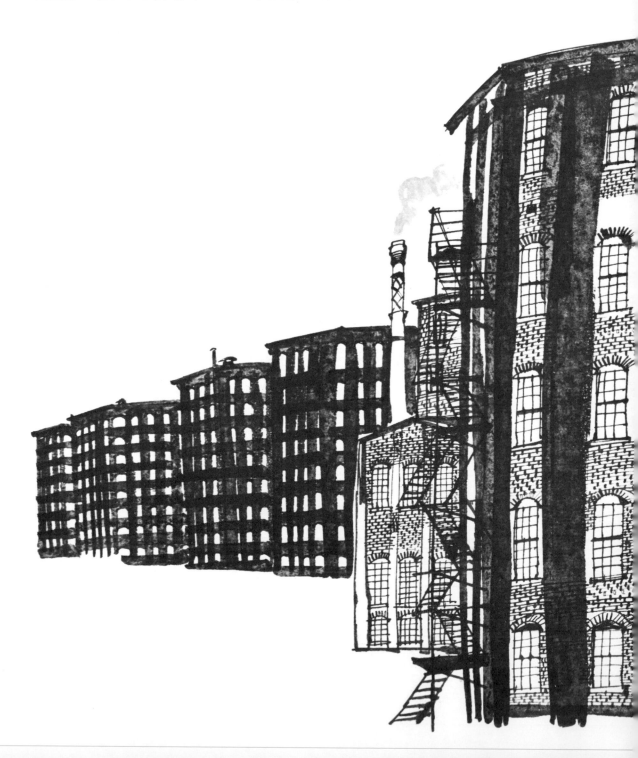

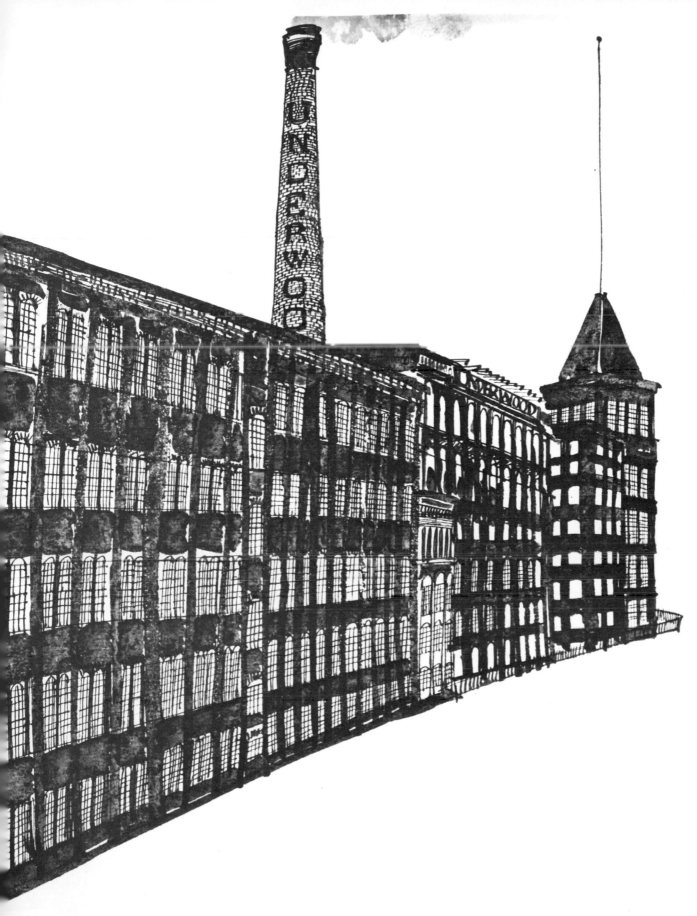

Index

Edited by Judith A. Levy
Designed by James Craig
Composed in ten point Optima by Noera-Rayns Studio Inc.
Black and white offset by Halliday Lithograph Corp.
Color offset in Japan by Toppan Printing Co., Ltd.
Bound by A. Horowitz and Sons